# INDUSTRIAL LOCOMO

# &

# RAILWAYS OF THE
# NORTH WEST OF ENGLAND

Gordon Edgar

AMBERLEY

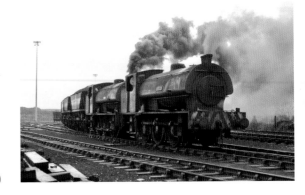

*Right*: Hunslet Austerity 0-6-0 saddle tanks *Warrior* and *Respite* at the head of a loaded MGR train at Bickershaw Colliery on a wet 8 December 1978. (John Sloane)

*Front cover*: The oldest locomotive in the fleet at Yates Duxbury's Heap Bridge paper mill near Bury was this veteran Andrew Barclay 0-4-0 saddle tank (W/No. 945 of 1904), seen working the exchange sidings on a winter's day in 1972. (Author's collection)

*Back cover*: Hunslet Austerity 0-6-0 saddle tank *Alison* (W/No. 3885 of 1964) showing her worth with a train of merry-go-round (MGR) wagons at Bold colliery on 5 November 1976. (John Sloane)

First published 2018

Amberley Publishing
The Hill, Stroud
Gloucestershire, GL5 4EP

www.amberley-books.com

Copyright © Gordon Edgar, 2018

The right of Gordon Edgar to be identified as the Author of this work has been asserted in accordance with the Copyrights, Designs and Patents Act 1988.

ISBN 978 1 4456 4938 2 (paperback)
ISBN 978 1 4456 4939 9 (ebook)

British Library Cataloguing in Publication Data.
A catalogue record for this book is available from the British Library.

Typeset in 10pt on 12pt Sabon LT Std.
Origination by Amberley Publishing.
Printed in the UK.

# CONTENTS

# INTRODUCTION & ACKNOWLEDGEMENTS

This is the sixth volume in this regional series of books examining the industrial locomotives and railways of England, Wales and Scotland. The North West region of England covered herein looks at Lancashire, Greater Manchester, Merseyside and Cheshire, stretching as far north

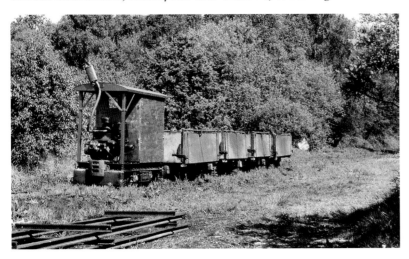

This Lister Blackstone 2-foot gauge (W/No.50888 of 1959) is returning empty peat wagons to the peat moss serving Middlebrook Mushrooms Ltd, Wilmslow, Cheshire, on 26 May 1989. (Author)

as Preston and across to Ellesmere Port in the west. Those railways in Cumbria have been excluded, having been covered in the first volume in this series.

The North West was the powerhouse of the Industrial Revolution and by 1860 Lancashire was producing in its mills half of the world's cotton, transported via its waterways. The Bridgewater Canal was built to transport coal from the mines around Worsley to the industrial areas of Manchester in the late eighteenth century, but within a century its importance had been overtaken by the railways, as the mining companies progressively established their own systems to transport their coal to market quickly and cost-effectively, not just for industry and household consumption but also to satisfy the growing demands of the main line railway companies as the railways in the district progressively expanded after the opening of the Liverpool & Manchester Railway in 1830.

Although canals had a significant part to play in the early years of the Industrial Revolution, the developing railways were very soon the preferred choice of freight transport, largely replacing the canals. In addition to the main line railway companies, many smaller private railways were established, over time ranging from extensive colliery systems, such as the Walkden Railways, at the ports of Liverpool, Manchester and Preston, right down to narrow-gauge tramways on the peat bogs of Chat Moss in Lancashire and at Wilmslow in Cheshire.

The last canal to be built was the Manchester Ship Canal (MSC), and upon opening in 1894 it was the largest in the world and was aimed at freeing the inland city of Manchester from its dependence on the historic Port of Liverpool. Despite the MSC's limited success, with the Port of Liverpool growing in importance and becoming the dominant port in the North West, manufacturing sites were soon attracted along the canal's banks, particularly after the railways of the extensive Manchester Ship Canal Company had been established, stretching along many parts of the canal between Manchester and Ellesmere Port.

As well as coal, chemical production had an equally important role to play in the region, particularly on the Wirral Peninsula and at Northwich in Cheshire; the production of sodium carbonate was important for the manufacture of glass, textiles, soap and paper. Many of these associated industries used their own private locomotives and railways, as will be discovered within these pages. Three centuries of glass production took place at St Helens, established there due to the ready supply of sand and coal with good transport communications by canal and railway.

As would be expected, by far the most dominant of industries in the North West region was coal mining, and no fewer than thirty-five pages of this book are devoted to the railway systems, facilities and locomotives of several collieries and coal concentration depots. In 1907 there were no fewer than 358 collieries in the Lancashire coalfield, but by vesting day this had reduced to eighty-six operational sites. Closures over the following four decades saw all NCB deep mines in Lancashire disappearing, with Parkside the very last to go, in 1993. The collieries at Bickershaw and Bold will have escaped the attention of very few steam railway enthusiasts, places that saw out the very last NCB steam locomotives in the North West in the early 1980s, some fourteen years after the end of steam on BR.

Ironically, the last industrial location to use steam traction in the North West, albeit on an irregular basis, was with the nuclear industry,

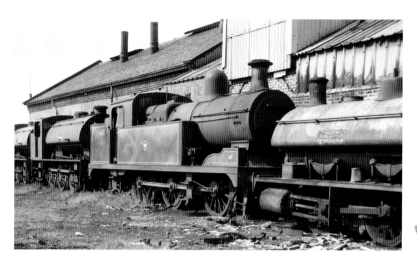

North Staffordshire Railway 0-6-2 tank *Sir Robert* (built at Stoke Works in 1923) had been out of service for eight months when this photograph was taken at Walkden Central Workshops on 30 June 1968. It was on 'death row' in the company of (right) former Pilkingtons (later NCB) Ravenhead colliery Kerr Stewart 0-4-0 saddle tank *Fairfield* (W/No. 4025 of 1919) and two Hunslet Austerity 0-6-0 saddle tanks, namely *Renown* (Hunslet W/No. 3697 of 1950) and *Wasp* (Hunslet W/No. 3808 of 1953). (Author's collection)

at Heysham nuclear power station, where two fireless locomotives were maintained in immaculate condition until 1992, on a standby basis to a battery-electric locomotive. The last conventional steam locomotives with the Central Electricity Generating Board had been retired a decade before, from the Agecroft power station in September 1981.

This book is not all about steam traction though, and in the post-steam era, from the 1980s, diesel locomotives continued to play an important part at many locations throughout the region, but with the decline of the traditional manufacturing industries, so too the number of locomotives and installations that they served was reduced. It is a sad fact that, of the locations covered in this book, just two concerns still

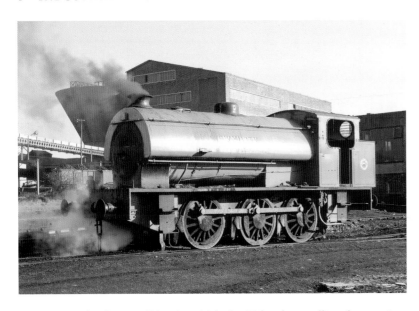

Epitomising the fine condition in which the Bickershaw colliery locomotives were usually turned out, as operations allowed, Newcastle-built Robert Stephenson & Hawthorns Austerity 0-6-0 saddle tank *Gwyneth* (W/No. 7135 of 1944) basks in the low winter sunshine outside the loco-shed at the colliery on 7 February 1975. (John Sloane)

call upon their own locomotives for internal shunting or trip working, which is a sobering thought when one considers the wealth of industry and its railways that at one time could be observed in the North West.

As with other books in this series, the period covered is primarily the last six decades, the photographs selected aiming to present some affinity with the industries which the railways supported. Within a book of this scope, it is an impossible task to cover every type of industrial railway operation, some installations having been rarely visited and photographed due to industrial and commercial sensitivities, but I have endeavoured to cover the principal locations and industries in what was a remarkably rich hunting ground for observers, using such diverse and fascinating locomotives on some of the largest industrial railway systems to be found anywhere in Britain. To present as much of this historical photographic material as possible I have refrained from including chapter introductions, but have made use of extended captions to the images, endeavouring to enlighten the reader on the operations concerned.

In compiling this book, I have consulted numerous works of reference published by the Industrial Railway Society, which always prove invaluable in tracing the sometimes complicated trails of some locomotives, and the history of the locations in which they served. I would like to record my gratitude to Roy Burt, John Sloane, Kevin Lane, Adrian Nicholls, Duncan McEvoy and Colour Rail and the Industrial Railway Society for making available historic material from their collections and archives. Without such support a work of this scope would have been impossible to produce. I would also like to thank Richard Stevens for not only providing some of his splendid action photographs and associated historical information, but also for reviewing the draft copy, although I accept full responsibility should any errors have crept in. I am also indebted to Keith Gunner, who solved the long-standing mystery of the loco at Stratford depot in July 1967 (shown on page 128 of the *London & Northern Home Counties* book) some fifty years on! It was in fact Hawthorn Leslie works No. 3791, built in 1932, in the process of being moved from CEGB West Ham power station, and on its way for scrap at G. J. Marshall of Battersea.

Finally, and by no means least, I would particularly like to pay tribute to my wife Valerie for her support and patience while I have been engaged in producing not just this book, but with this entire series.

Gordon Edgar
Ripon, North Yorkshire
December 2017

# THE MANCHESTER SHIP CANAL &
# THE TRAFFORD PARK ESTATE RAILWAYS

The Manchester Ship Canal (MSC) opened for business in 1894 and the Manchester Ship Canal Company's (MSCC) railways grew rapidly to cope with the new business as the canal and docks traffic expanded and companies began to establish factories on the canal estates. The MSC Railway was the largest industrial railway system in the country and at its zenith comprised some 230 miles of running lines and sidings, extending along the canal for some 36 miles from Eastham Locks near Ellesmere Port in the west to the centre of Manchester. The system actually comprised six separate sections and never formed a complete running line between Manchester and Ellesmere Port, although at its peak it did serve most major facilities and docks situated along the entire length of the canal. Between 1897 and 1954 the MSCC purchased a total of eighty steam locos, mostly new ex-factory, but dieslisation rapidly took hold from the early to mid-1960s, and by 1966 the diesel fleet comprised a total of forty locos. Steam traction finally came to an end on 30 June 1966 without ceremony, a period which coincided with the trend for shipping to move towards containerised traffic, along with the requirement for larger ports, resulting in the decline of business for both the canal and its railways. In 1970 the MSCC Board decided to withdraw rail facilities for the 100 plus companies located on the Trafford Park Estate. By 1978 the MSC Railway comprised just 13 miles of through route and 40 miles of track and this declined further until 1994, after which MSC Railway traffic was confined only to the Trafford Park–Barton Dock and Ellesmere Port–Stanlow sections, the Mode Wheel hub and railways north of the canal finally being confined to the history books. On 22 March 1976 (above), 283 hp Rolls-Royce 'Sentinel' 0-6-0 diesel-hydraulic No. 3005 (W/No. 10162 of 1963) is seen at work with a rake of petroleum tankers from the Shell Stanlow Refinery at Ellesmere Port. (Roy Burt)

*Right*: The transitional period between steam and diesel traction at the MSC Railway's Mode Wheel depot in the mid-1960s, where a work-stained Hudswell Clarke 0-6-0 tank No. 31 (W/No. 679 of 1903) stands alongside the depot coaling stage, in the company of a newly delivered 255 hp Rolls-Royce 'Sentinel', with one of the slightly older Hudswell Clarke diesels behind. Mode Wheel was the hub of the MSC Railway and the shed and workshops had been established there in 1900. The workshops and paint shop comprised six roads, while the long running shed had three roads, separated from the workshops by two central sidings, the whole complex comparable to any main line depot. In 1962 the shed allocation comprised some forty steam and ten diesel locos. By 1966 diesel had replaced steam traction entirely, by which time the fleet comprised some forty diesel locos. But sadly, the fortunes of the railway were soon to change with the decline in shipping for imports and exports and the knock-on effect for BR rail traffic and consequently a reduced requirement for MSC Railway transfer trip workings between the BR exchange yards, MSC docks and businesses. (Author's collection)

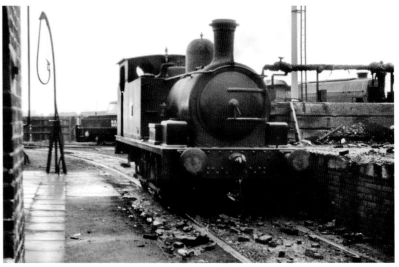

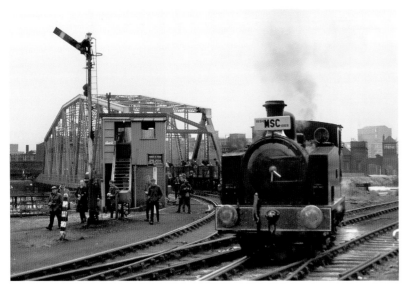

*Left*: Regular steam working bowed out on the MSC Railway on 30 June 1966, with Hudswell Clarke 'long tank' No. 67 (W/No. 1369 of 1919) dropping its fire at Mode Wheel shed after its last shift. Sister 0-6-0 tank No. 70 (W/No. 1464 of 1921) was returned to the MSC Railway on 14 September 1969 and is seen heading a railtour of the still extensive MSC Railway system, crossing the Barton Railway Swing Bridge which connected Mode Wheel with Trafford Wharf. The last MSC diesel loco crossed this structure on 31 October 1981, after which the bridge was removed, and the track lifted to Mode Wheel, thus effectively severing Trafford Park Estate from the rest of a once integral MSC system. Both locos survived into preservation; No. 70 is based on the Swindon & Cricklade Railway and No. 67 at the Middleton Railway in Leeds. (Author's collection)

*Opposite page*: Hudswell Clarke 0-6-0 diesel-mechanical D6 (W/No. D1191 of 1961) working past the CWS Sun Flour Mills on the Trafford Park Estate section of the system in the 1960s, at a time when rail freight traffic was heading for a decline on the entire MSC Railway. (Colour Rail)

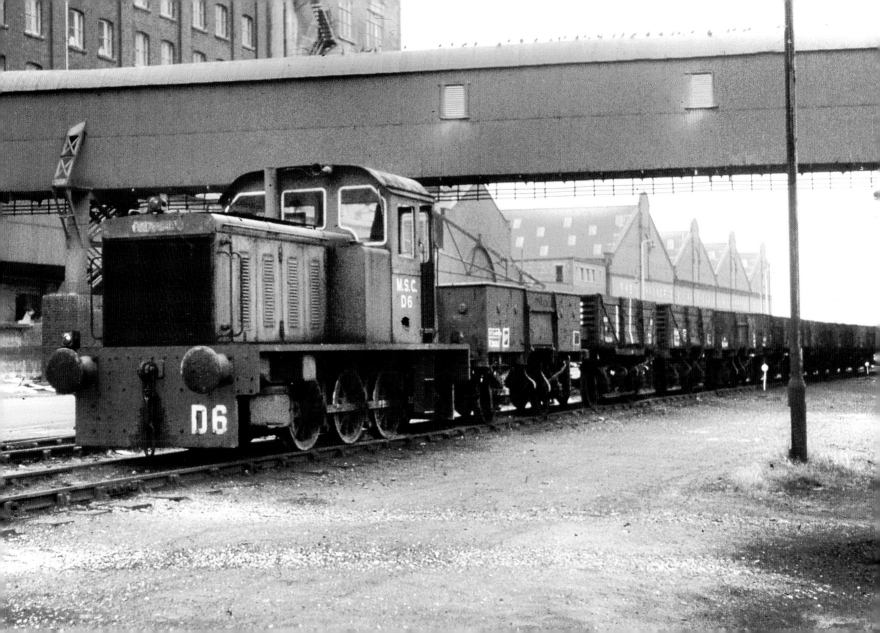

*Right*: The MSC Railway's 'open-air' stabling point at Ellesmere Port on
22 March 1976 with 'Sentinel' 0-6-0 diesel-hydraulics Nos 3004, 3003 and
3002 (W/Nos 10147, 10146, and 10145 of 1963 respectively). MSC steam
traction ceased here in 1963, replaced by five 283 hp six-coupled 'Sentinel'
diesel-hydraulic locos (3001–3005), deployed between Ellesmere Port and
Stanlow to provide shunting and transfer facilities between BR and the dock
estate refineries, chemical works and factories on the detached Ellesmere
Port system at the western extremity of the MSC system. The locos were
routinely returned to the main MSC Mode Wheel workshops for repair as
required. Twenty years later, in July 1996, MSC Railway operations ceased
at Ellesmere Port, following a general decline in rail traffic business from the
area's industrial concerns. By this time, at Trafford Park, there was a much
reduced MSC fleet, leaving just one Hudswell Clarke and three tandem-fitted
'Sentinels' to soldier on from the modest 1981-built Barton Dock shed, next
to the Kellogg factory, undertaking the few remaining duties along that
section of line, mainly container trains, but also at the Cerestar Wharf.
(Roy Burt)

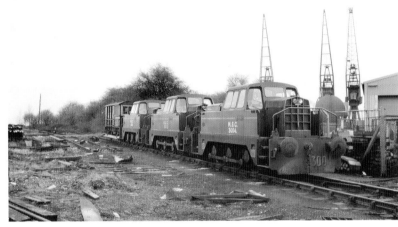

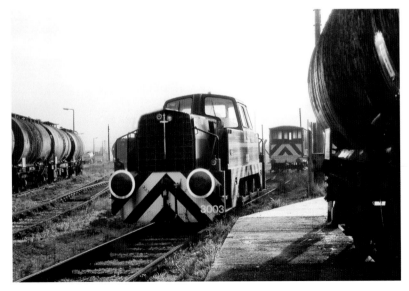

*Left*: On 12 October 1990, 'Sentinel' 283 hp 0-6-0 diesel-hydraulic
No. 3003 (W/No. 10146 of 1963) is waiting at the BR exchange sidings
stabling point and wagon repair sidings to undertake the next transfer along
the MSC Railway metals between BR and the oil refineries at Ellesmere
Port and Stanlow. The MSC locos had running rights over the BR main line
between Ellesmere Port East and West Junctions. The fleet of five Ellesmere
Port-allocated 'Sentinels', later reduced to four, were mainly employed on oil
refinery traffic duties in the area, but also served the reception sidings at the
nearby Associated Octel Ltd chemical works (*see pages 98 and 100*). None
of the five MSC Rolls-Royce 'Sentinels' from Ellesmere Port survive today.
(Author)

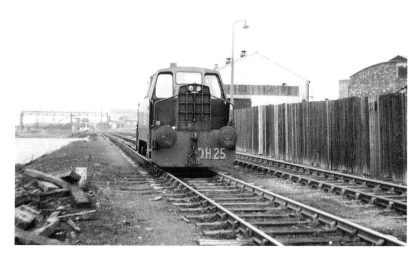

*Left*: MSC 255 hp Rolls-Royce 'Sentinel' four-wheel diesel-hydraulic DH25 (W/No. 10228 of 1965) is seen running light engine near Mode Wheel on 31 March 1971. The company had favoured both steam and diesel products from Hudswell Clarke from 1902 and 1959 respectively, but in the mid-1960s took the decision to switch allegiance to the widespread industry-respected and reliable Rolls-Royce 'Sentinel' diesel locomotives, purchasing a total of twenty-three, comprising five six-coupled 283hp examples for Ellesmere Port/Stanlow duties and eighteen 255 hp four-wheel diesel-hydraulic locos based at Mode Wheel shed for other MSC Railway and Trafford Park Estate duties. As it transpired, even their reign proved to be short-lived, for in 1970 two of the 255 hp examples were sold on to Bowater at Ellesmere Port, and they were closely followed by five more, sold on to Thomas Hill at Rotherham for eventual resale, and in 1972/73 a further eight were disposed of, leaving a mixed MSC fleet of just fifteen Hudswell Clarke and 'Sentinel' diesels to undertake the remaining and by then rapidly declining MSC Railway duties. (John Sloane)

*Right*: Bowaters (UK) Pulp and Paper Mills at Ellesmere Port was located alongside the Manchester Ship Canal, between the junctions of the canal with the Shropshire Union Canal and the River Mersey. Bowaters constructed their newsprint and paper mill between 1930 and 1934, enjoying the benefit of both rail transport and shipping. 'Sentinel' 255 hp four-wheel diesel-hydraulic DH15 (W/No. 10174 of 1964) and its sister loco DH16 (W/No. 10175 of 1964) were both purchased from the MSCC in November 1970 and, unlike the Royal Blue livery carried by most of the MSC Railway's 'Sentinel' fleet, they were turned out in a striking scarlet red livery, but initially still retained the MSC fleet running numbers. They eventually replaced the shunting duties previously undertaken by three Andrew Barclay 0-4-0 fireless locos and a Class 165DE Ruston & Hornsby loco. On 22 March 1976 DH16 is seen working at the factory, but their tour of duty at Ellesmere Port sadly proved to be short-lived, and this photograph was taken just four years before the closure of the Bowater mill itself. DH16 is now preserved on the West Somerset Railway. (Roy Burt)

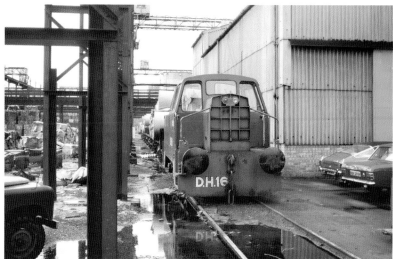

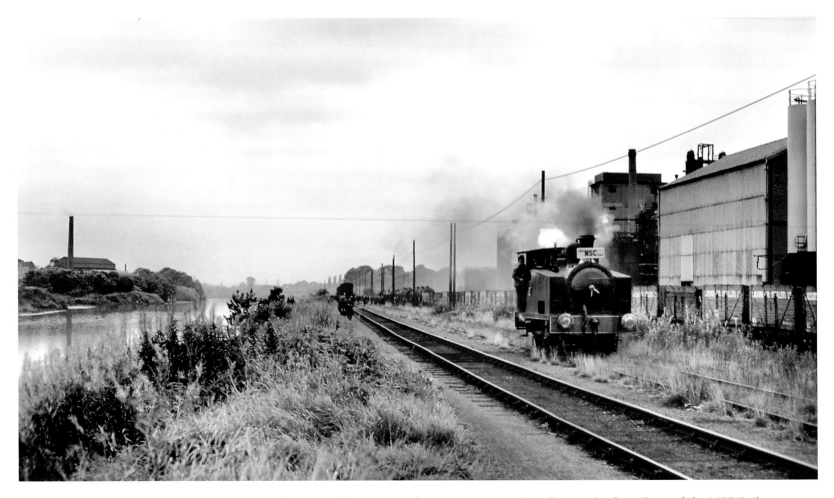

On 14 September 1969, Hudswell Clarke 0-6-0 tank No. 70 (W/No. 1464 of 1921) is rounding the rolling stock of a railtour of the MSC Railway system alongside the private sidings of Lancashire Tar Distillers Ltd and the Manchester Ship Canal at Cadishead (this railtour is also featured on page 8). The MSC Railway through route between Weaste Junction and Partington (Cadishead) was eventually closed in July 1978, following dwindling traffic levels on the MSC Railway. (Author's collection)

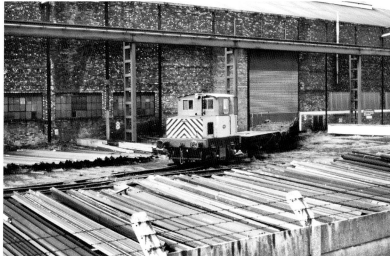

*Left*: The closing years of the MSC Railway system with Hudswell Clarke 0-6-0 diesel-electric D2 (W/No. D1187 of 1960) on 4 September 1988, maintained as reserve to two sister Hudswell Clarke locos, outside a new purpose-built depot and compound established at Weaste. This was a far cry from the halcyon days of this once vast system, which, even in the early 1950s, boasted a fleet of over seventy steam locos based at Mode Wheel depot and out-stationed at Partington (Cadishead), No. 9 Dock, Ellesmere Port, Runcorn and Latchford. During the 1970s almost twenty diesel locos from the dwindling fleet were disposed of and by the mid-1980s only three were required to fulfil the company's commitments. In 1988 the original, and by then dilapidated, Mode Wheel depot and workshops were finally closed and replaced by this new structure and secure compound. Upon closure of the oil terminal served by locos from this new shed, the last MSC duties were performed in March 1994, handling the BR oil traffic from Port Clarence, leaving just Barton Dock shed as the MSC Railway base. (Author)

*Right*: Dozens of companies established their businesses on the Trafford Park Estate from the early twentieth century, attracted by the excellent connections, with a comprehensive network of railway lines radiating throughout the Estate and served by both shipping and main line railway communications. Rail activity by the MSC's railway department locos was buoyant right up until the late 1960s, by which time motor transport had taken a serious hold on freight distribution. Throughout the Trafford Park Estate railway system's existence numerous companies were required to provide shunting facilities within their own works premises if they desired to interface with the MSC's railway department transport facilities. Notable companies using their own locos for shunting, although not exclusively, were Brown & Polson (CPC), Procter & Gamble, Courtaulds, Metropolitan Vickers, Redpath Brown, Shell-Mex and Taylor Brothers. On 21 October 1984, this Frank Hibberd Planet four-wheel diesel-mechanical (W/No. 3886 of 1958) is seen within the works of the British Steel Corporation (Redpath Engineering Ltd) at Westinghouse Road. (Roy Burt)

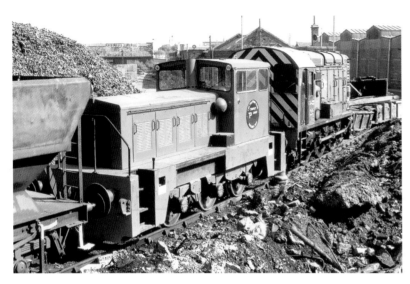

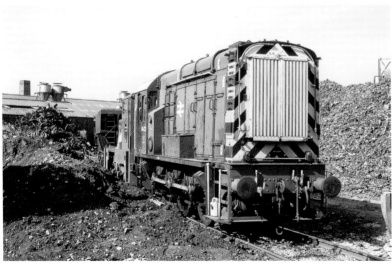

*Above and below left*: Following the contraction of MSC Railway operations, the Trafford Park Estates Company (TPEC) established a depot at Third Avenue on the Trafford Park Estate; its seven-loco fleet handled the Cerestar starch, Norton Metals scrap metal and Castle Services general freight traffic. The TPEC's former BR Derby Works 1958-built Class 08 0-6-0 350 hp diesel-electric No. 08423 was, on 28 May 1989, at the Norton Metals yard, along with a Thomas Hill Vanguard 272 hp six-wheel diesel-hydraulic (W/No. 180V of 1967). The '08', still bearing a faded BR blue livery, was soon to receive a coat of green paint and logo, bringing it in line with the company's corporate identity. The TPEC had little success in developing further rail freight contracts and Cerestar's decision to withdraw from factory gate rail freight distribution in 2001 was the death knell for TPEC and this part of the estate railway system, leaving only the Trafford Park to Barton Dock section active for Containerbase's intermodal services (*see page 18*). In more recent years No. 08423 (identified as H011) has seen use at Flixborough Wharf, Scunthorpe, and in 2017 was on-hire and working at Teesport. The Vanguard, originally with the NCB at Wolstanton colliery as their No.12D, did not survive the cutter's torch and was not an entirely successful design. (Author)

*Opposite page*: CPC (Corn Products Refining) had a corn milling and glucose plant on the Trafford Park Estate with a 700-ft MSC wharf where imported maize was unloaded from seagoing ships directly into the company's silos. Coal was brought almost to the factory gate from BR by an MSC loco. Until the late 1970s, this internal railway was worked by a solitary Andrew Barclay 0-4-0 saddle tank (W/No. 1964 of 1929), which had spent all its working life there. Outside the plant, the line and road traversed a sharp reverse curve, dating back to when Trafford Park was being industrialised from a country estate and Trafford Hall, demolished in 1939, was situated in the area now occupied by the CPC car park. On 3 June 1977, the Barclay has brought empties out of the works and is running forward to the crossover to set back on the left-hand road and onto the loaded wagons. (Richard Stevens)

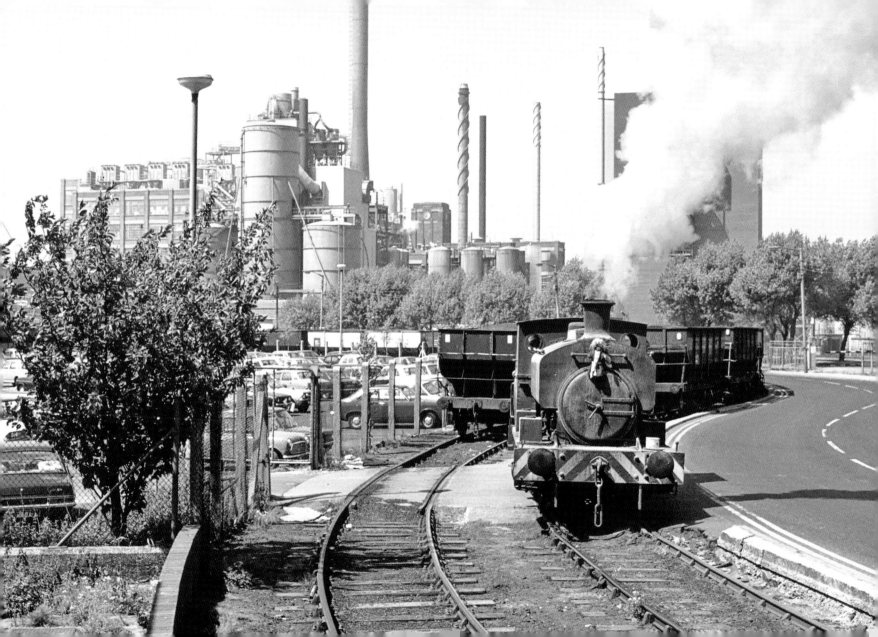

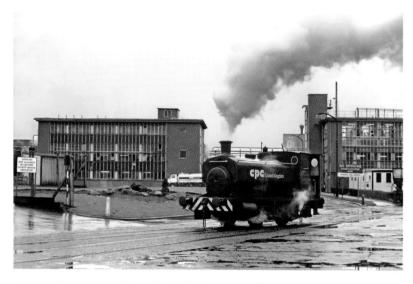

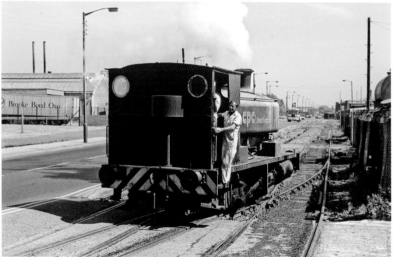

*Above left*: CPC's Andrew Barclay trundles out of the works complex to the exchange sidings on the Trafford Park Estate's private railway system in December 1971. The company had traditionally relied upon BR to provide a steam shunting loco on a short-term hire arrangement when theirs was unavailable, usually a L&YR Aspinall 'Pug' 0-4-0 saddle tank, and this arrangement continued well into the 1960s (*see page 46*). The cornflour produced is flammable, but the factory's directive of prohibiting 'naked lights' apparently did not apply to steam locos! The factory now processes more than a thousand tonnes of maize per day, extracting starch, protein, oil and fibre for industrial use. Well over half the products made are used by the food and drink manufacturing industry, but the company no longer uses rail directly from the factory. (Author's collection)

*Below left*: The CPC Barclay 'Pug' switches tracks alongside Trafford Park Road on 3 June 1977. The crew's white overalls were not the most practical attire for working on the footplate of a steam locomotive, but they would have been completely appropriate within the factory complex and were undoubtedly standard issue for company employees. (Richard Stevens)

*Opposite page*: On 3 June 1977 the Andrew Barclay is in the process of propelling a rake of loaded coal wagons into the works. At one time, CPC had traded in the UK as Brown & Polson, a well-known and long-established brand, but this company had been acquired by CPC as far back as 1935. Steam continued in use until summer 1978, the Barclay being the last active steam loco working on the Estate. On a change of ownership in 1987 the works became known as Cerestar, and then in 2002 Cerestar was acquired by Cargill. The plant is still in operation, but was converted to process home-grown wheat in 2008. For many years under Cerestar ownership, some of the factory's output was shipped out by rail in purpose-built tanker wagons (not a feature of operations in the 1970s), handled by a Trafford Park Estate loco, but this had ceased by 2001. (Richard Stevens)

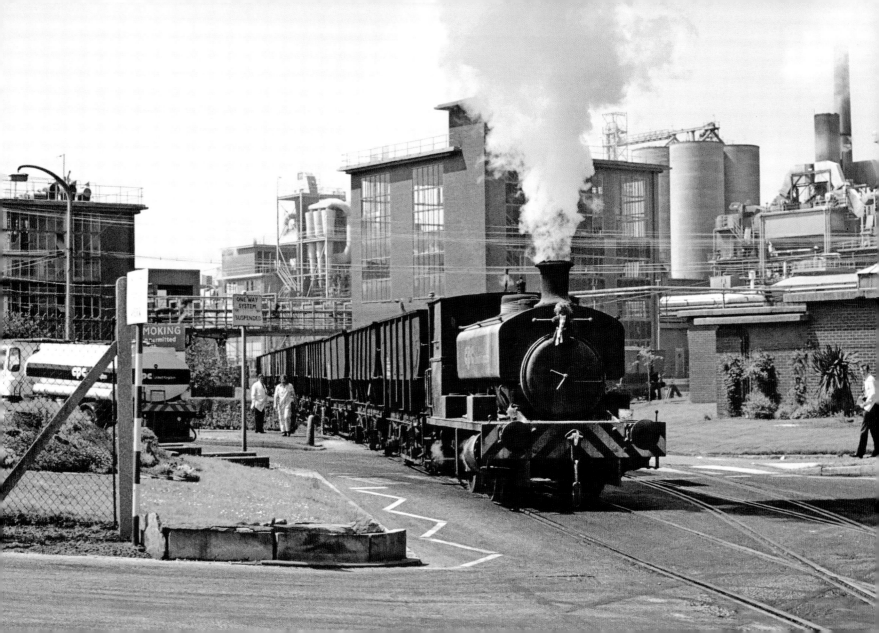

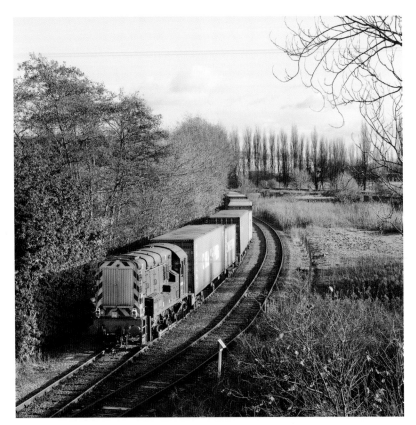

*Right*: On 18 June 2012, No. 09009 leaves Barton Dock Containerbase terminal in charge of what will become the 4L18 11.28 GB Railfreight service to Felixstowe from Trafford Park intermodal terminal. This line serving the Barton Dock terminal remained in use, initially with Freightliner, and latterly GB Railfreight services, until December 2012, when rail freight services were finally withdrawn from the Estate. (Duncan McEvoy)

*Left*: Belying the built-up nature of the surroundings, GB Railfreight No. 09009 arrives at the Containerbase intermodal terminal at Barton Dock, on the Trafford Park Estate, heading what was the incoming 4M04 01.48 Felixstowe Port to Trafford Park GB Railfreight service on 5 December 2012, just before cessation of rail services entirely on the former Trafford Park Estate railway system. The MSCC owned the track between Trafford Park and the Containerbase intermodal terminals, and this section of the system also served traffic from the Kelloggs cereal products factory until 1980, when the company moved entirely to road distribution, its new bespoke larger-sized pallets for distribution being incompatible with rail wagons and intermodal containers for maximum product payload. At its peak the Trafford Park Estate railway system covered some 26 miles, and by an 1898 agreement between the Estates company and the Ship Canal company the Estate system was operated by locos from the MSC Railway. The estate and its railway gradually fell into decline from the 1960s and rail transport on all other sections, except this Barton Dock branch, ceased by 2001. (Duncan McEvoy)

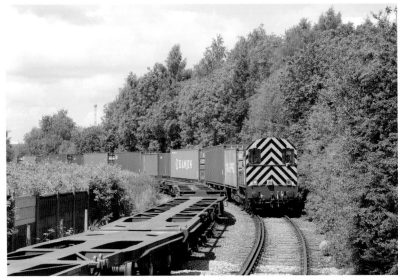

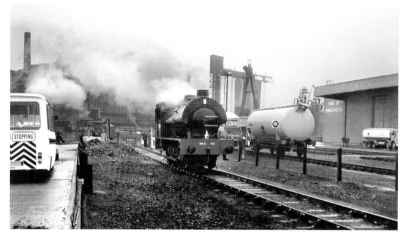

*Right*: Robert Stephenson & Hawthorns 0-6-0 saddle tank WD150 *Warrington* (W/No. 7136 of 1944 and rebuilt in 1969 by Hunslet, W/No. 3892) was exhibited at the MSCC E Group Sidings alongside the Port of Manchester offices at Trafford Park in the early 1970s. The Austerity was maintained at the erstwhile Dinting Railway Centre, and was a working exhibit at a rail freight promotional event on the Estate. (Author's collection)

*Left*: The two locos employed on the remnants of the once vast Trafford Park Estate network on 5 April 1991 were TPEC's Yorkshire Engine 'Janus' class 440 hp 0-6-0 diesel-electric *R. A. Lawday* (W/No. 2878 of 1963) and ex-BR 350 hp 0-6-0 diesel-electric No. 08423, both stabled on the track parallel to the Trafford Park Road. They were employed moving wagons between the BR network exchange sidings and the Norton Metals scrapyard and the Cerestar works. Upon cessation of rail traffic on this section of the Estate, both were acquired by RMS Locotec as hire locos. The 'Janus' is now to be found on the Weardale Railway and No. 08423 is at PD Ports, Teesport. (Author)

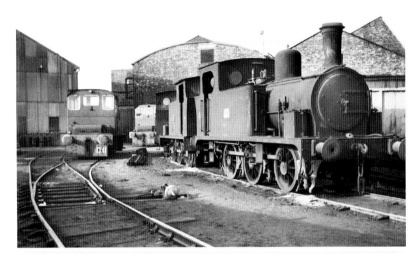

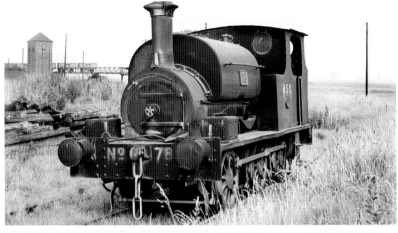

*Above left*: The MSC Railway originally had a penchant for Hunslet's products, but from 1902 changed their allegiance to Hudswell Clarke, who continued to supply the six-coupled locomotives so synonymous with the railway until 1927. By the time of this 1963 scene at Mode Wheel the steam locomotive fleet had all but been usurped by diesel traction and the Hudswell Clarke diesel 'interlopers' had already made their mark, although from 1963 Rolls-Royce 'Sentinels' became the preferred choice. In this transitional scene, veteran Hunslet 0-6-0 tank No. 20 *Glasgow* (W/No. 732 of 1900) is in the company of two Hudswell Clarke tanks and two new 0-6-0 diesel-mechanicals, D11 (W/No. D1265 of 1962) and D12 (W/No. 1266 of 1962). (Author's collection)

*Above*: Hudswell Clarke 0-6-0 saddle tank No. 78 (W/No. 1584 of 1927) is dumped out of use in isolation on the marshes alongside the Manchester Ship Canal in the late 1950s. It was scrapped around 1961. (Author's collection)

*Left*: Andrew Barclay 0-4-0 fireless (W/No. 1938 of 1927) at Procter & Gamble's Trafford Park factory in November 1966, the company at that time still receiving and despatching products by rail in the hands of the MSC locos. (Author's collection)

# 2

# THE PORT OF PRESTON

The Port of Preston was developed by Preston Corporation from 1882, when the Dock Navigation Company and its associated railway were acquired. The Ribble river channel was subsequently diverted and deepened, which enabled the opening in 1892 of the 40-acre Albert Edward Dock, the largest single dock in Europe. The early modest facilities were gradually developed to include a variety of rail-served warehouses, a hydraulic power house and a hospital. A rail connection via Fishergate tunnel and the notorious 1 in 29 gradient to the main line alongside Preston station was soon completed. The early development of trade was chiefly for foreign markets and by 1900 around 170 vessels were being unloaded each year, the dock handling a variety of general cargoes including bananas, timber, livestock, china clay, wheat, cotton products, and coal. Considerable volumes of wood pulp were also handled, destined for the East Lancashire paper mills (*see chapter 13*). During the First World War munitions were exported and oil storage tanks installed at the west end of the dock. A constraint for the port was the constant requirement for dredging of the River Ribble and the frequency of additional water-borne leisure traffic in the form of paddle-steamers to the Isle of Man, North Wales and Blackpool. Despite the development of roll-on roll-off ferries to and from Larne and buoyant general cargo throughout, which resulted in good returns for the port

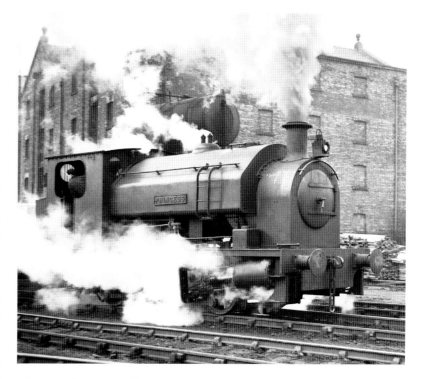

*Above*: William Bagnall 0-6-0 saddle tank *Princess* (W/No. 2682 of 1942) hard at work at a then busy Port of Preston on 2 February 1957. *Princess* was delivered before the war, and was the only Bagnall in the fleet fitted with 'half-height' steps on the saddle tank. (Author's collection)

during the 1960s, a combination of dockers' strikes in 1969/70, and the shipping trend towards larger vessels and intermodal containers, led to the decline of business and the dock was formally closed on 31 October 1981.

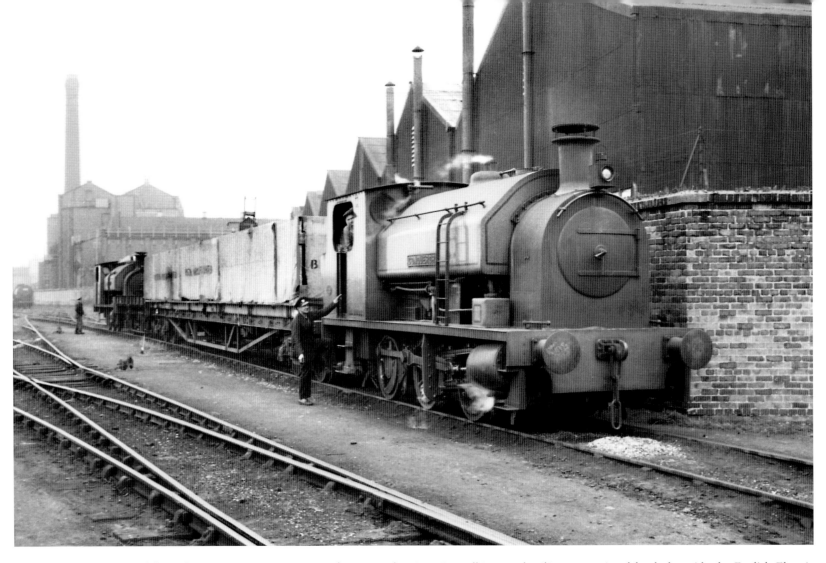

William Bagnall 0-6-0 saddle tank *Conqueror* (W/No. 2833 of 1945) and a sister Bagnall 'top and tail' an exceptional load alongside the English Electric (formerly Dick, Kerr & Co.) works in Strand Road on the Port of Preston system. (Author's collection)

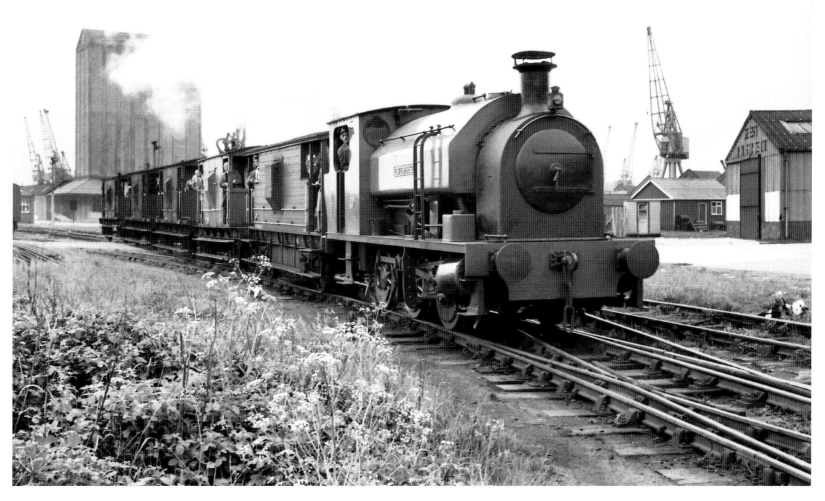

A Railway Correspondence & Travel Society brakevan tour in the mid-1960s, passing the grain silo near the south-east corner of the docks system, hauled by William Bagnall 0-6-0 saddle tank *Enterprise* (W/No. 2840 of 1945). (Peter Eckersley – author's collection)

*Right*: William Bagnall 0-6-0 saddle tanks *Courageous* (W/No. 2842 of 1948) and *Princess* (W/No. 2682 of 1942), dumped out of use outside the locomotive shed at Preston Dock on 4 May 1969, their work having been taken over by the newly delivered Rolls-Royce 'Sentinel' diesel-hydraulic locomotives. The timber-built three-road shed and workshops were situated between the Strand Road exchange sidings and the dock. Geest bananas were for many years handled at the south dock and loaded into white vacuum-fitted vans for further transport by BR. Most, if not all, of the Bagnalls were fitted with steam heating pipes, fitted only at the rear of the locos, to steam-heat the vans and to assist the ripening process while the fruit was in transit to market. A shipment of bananas required three locos to work this traffic when a ship docked in order to maintain warmth in the vans, two working on the quayside and one handling empties from the exchange sidings for eventual loading at the dock. (John Sloane)

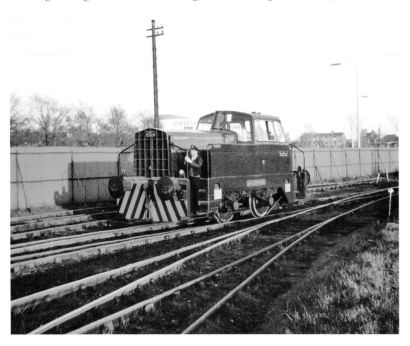

*Left*: The new order of the day at the Port of Preston Authority's Preston Docks railway at the Strand Road exchange sidings on 10 April 1969 was Rolls-Royce 'Sentinel' four-wheel diesel-hydraulic *Enterprise* (W/No. 10282 of 1968) in the striking and traditional lined green livery before all-over yellow became the widespread industry norm for such locomotives, thereby providing improved visibility for track workers and staff at the expense of corporate presentation and overall aesthetics as previously enjoyed. (John Sloane)

*Opposite page*: The Port of Preston's Armstrong Whitworth 0-6-0 diesel-electric *Duchess* (W/No. D8 of 1932) at the Port in the early 1960s. Originally an Armstrong Whitworth 'demonstrator loco', it was placed on loan to the London & North Eastern Railway and then the Southern Railway in 1932. Further trials followed with the Hartley Main Railway, Lever Brothers at Port Sunlight and finally Ribble Navigation at Preston, who decided to purchase the loco in 1935, where it worked alongside the William Bagnall steam fleet until its withdrawal in 1969, upon the arrival of the new 'Sentinel' diesels. (Author's collection)

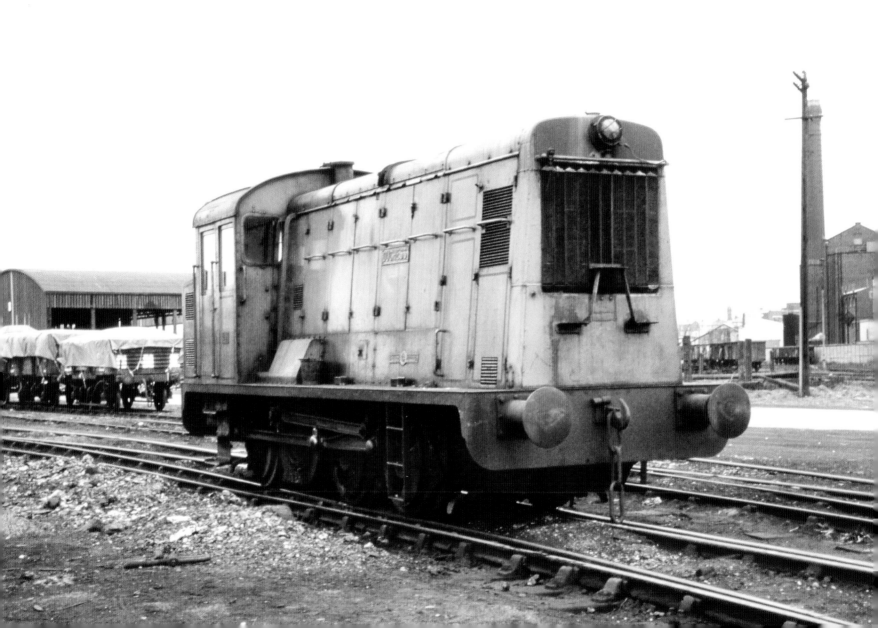

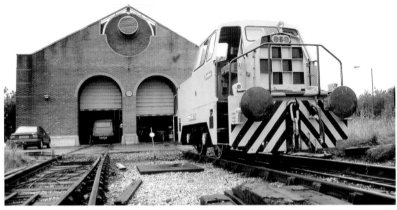

*Left*: 'Sentinel' four-wheel diesel-hydraulic *Progress* (W/No. 10283 of 1968) outside the award-winning Port of Preston Authority loco-shed on 5 September 1988. Although the building still stands, it is isolated from the surviving railway system, and is now used as a road vehicle workshop. (Author)

*Above*: By now in the ownership of the Ribble Steam Railway, *Progress* stands outside the loco-shed on 10 September 1993, having been purchased the previous year. It is now maintained a mere 'stone's throw' away from this Preston Council-owned depot and sees regular use on the railway transferring tanker wagons from the Strand Road exchange sidings to the Total UK Ltd Riversway bitumen terminal. (Author)

*Opposite page*: To fulfil its contract of delivering and shunting the bitumen tankers, the Ribble Steam Railway has three 'Sentinel' four-wheel diesel-hydraulic locomotives at its disposal. In the rain on 3 July 2017, *Energy* (W/No. 10226 of 1965) draws six loaded tankers away from Strand Road exchange sidings. It was acquired from MSCC in 2004 (fleet No. DH23) and is mainly held as reserve to the original Port of Preston 'Sentinels', *Enterprise* and *Progress*, usually entrusted to these duties. (Author)

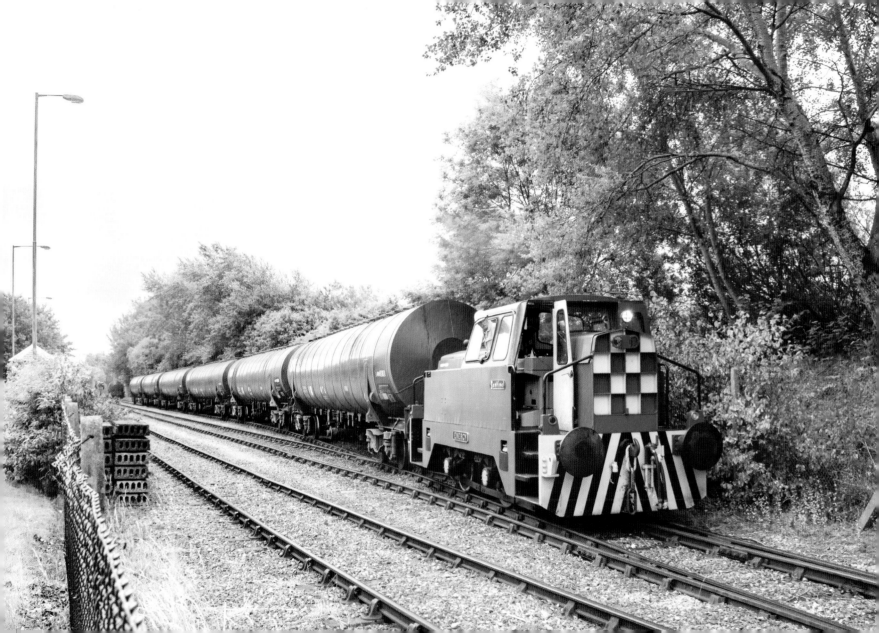

*Right*: Fourteen empty bogie tankers are lifted from Riversway sidings by William Bagnall 0-6-0 saddle tank *Courageous* (W/No. 2680 of 1942) around 7.00 a.m. on Monday 3 July 2017. The 'ICA-G' tanker wagons would be returned to Lindsay Refinery by Colas Rail Freight as train 6E32. These intermittent weekly workings have taken place since December 2004 along the private 1.5-mile-long branch line and are normally undertaken by diesel traction of Ribble Rail, a subsidiary of the Ribble Steam Railway. This steam substitution was only the second occurrence, with *Courageous* temporarily loaned to Ribble Rail proving that steam working for industry is not quite over, just yet! (Author)

*Below*: Steam traction was employed to move loaded bitumen tankers from the Strand Road reception sidings to Riversway bitumen terminal on 3 July 2017. The loaded tankers having arrived from Lindsay Refinery by Colas Rail Freight train 6M32, William Bagnall 0-6-0 saddle tank *Courageous* gets to grips on the wet and greasy rails with its 700-tonne trailing load destined for the bitumen terminal. (Author)

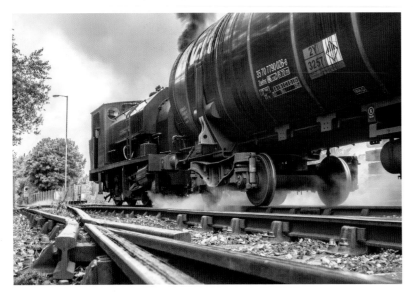

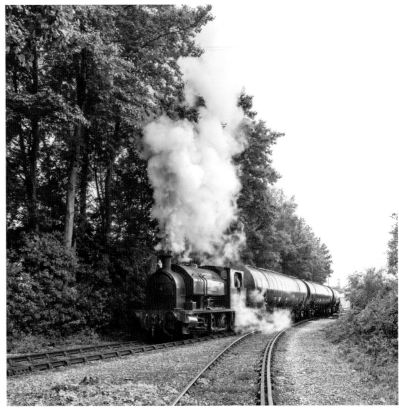

*Opposite page*: Early on Monday 3 July 2017, *Courageous* is working hard on the 1.5-mile branch with its 700-tonne loaded bitumen train, crossing the 1985-built Riversway skew road and rail swingbridge above the channel and the 660-foot lock which allows waterways traffic to gain access to the Riversway Docklands (*the former Preston Albert Edward Dock, featured on page 32*). The Ribble Steam Railway kindly granted prior permission to access the railway under supervision to capture these unusual scenes. (Author)

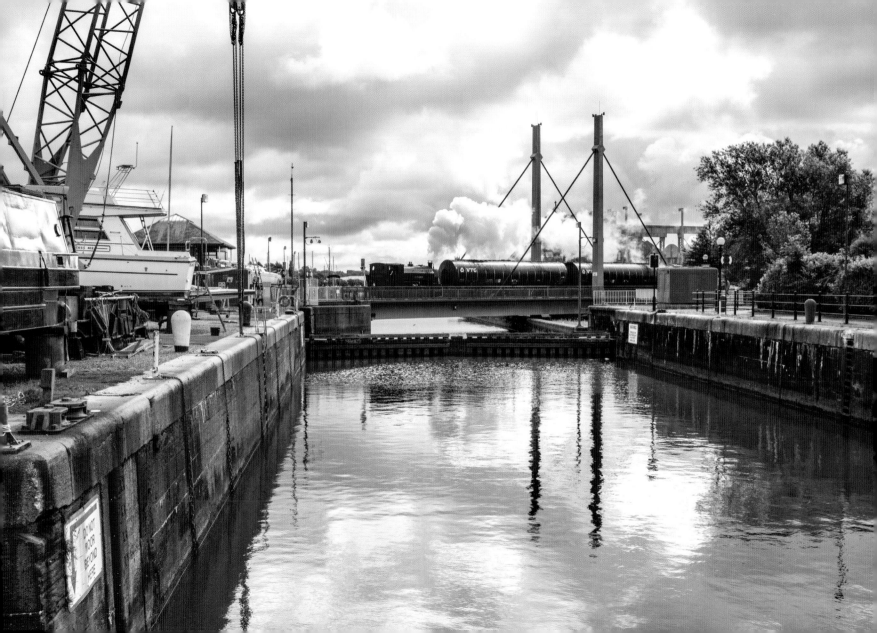

*Right*: William Bagnall 0-6-0 saddle tank *Energy* (W/No. 2838 of 1946), in a lined apple-green livery, stands outside the Port of Preston Docks shed in the 1960s. The Port had seven Bagnalls in their fleet, a type of which a total of only eighteen were built. The present day Ribble Steam Railway's *Courageous* is in fact the first of this design, but it was delivered new to Birchenwood Gas & Company at Kidsgrove, Staffs, and never worked at the port. The 1986 replacement brick-built diesel loco-shed (featured on page 26), with its curved ends and high roof, was located at Nelson Road on the western extremity of the present-day Ribble Steam Railway, and even won an award from the Brick Development Association. Sadly, it is not available for use by the heritage railway. In all there were around 28 miles of dock lines at the Port of Preston at its zenith, and there were also private sidings worked by other private companies' locos at Lancashire Tar Distillers, and the T. W. Ward scrapyard and ship breaking business at New Diversion Quay on the River Ribble, close to the Port Authority's loco-shed. (Author's collection)

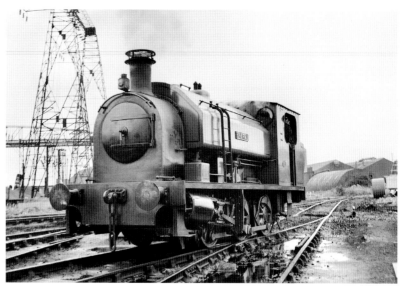

*Left*: An earlier view of sturdy *Energy* outside the Port's loco-shed opposite Diversion Quay on 2 February 1957. (Author's collection)

*Opposite page*: *Energy* was seemingly a popular loco, for here it is again, making up a train in the mid-1960s. The names *Energy*, *Enterprise* and *Progress* were transferred to the three 'Sentinel' diesels from the Bagnalls. The replacement of nine Port Authority locos in June 1968 by the 'Sentinels' reflected the contraction of the Port's rail business, especially with the decline of the Lancashire paper industry and consequent reduced demand for wood pulp. The increasing use of intermodal containers handled at larger ports elsewhere in the country also had its part to play. Following the dock's closure, the railway was retained for the petroleum and bitumen tank farm traffic, it being re-sited on a completely new alignment close to the River Ribble and the installation of the skew swingbridge at Riversway. This is the route still used today by the Ribble rail-hauled bitumen traffic and the heritage services of the Ribble Steam Railway, a remarkable example of British railway preservation and industry working together for mutual benefit. (Author's collection)

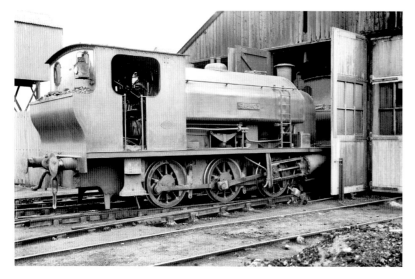

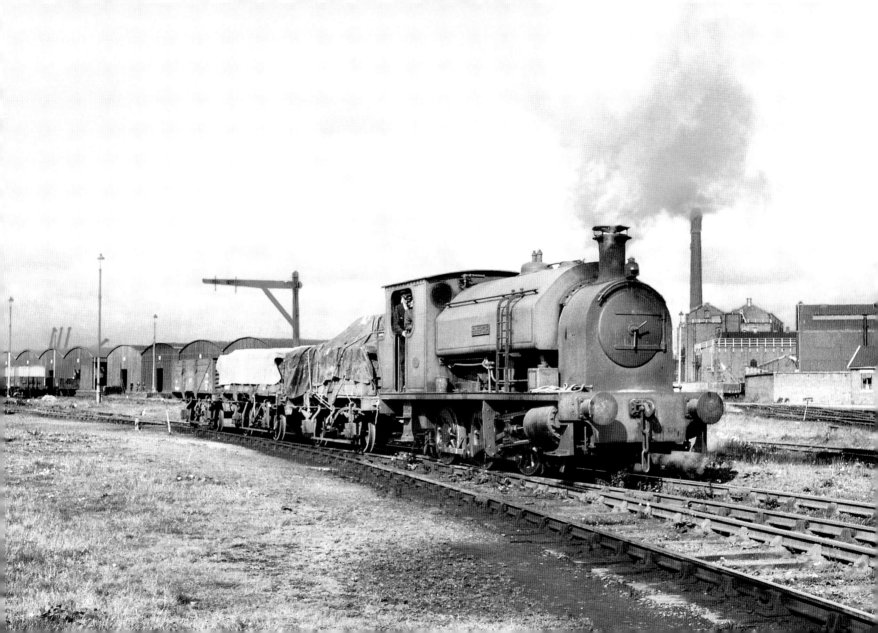

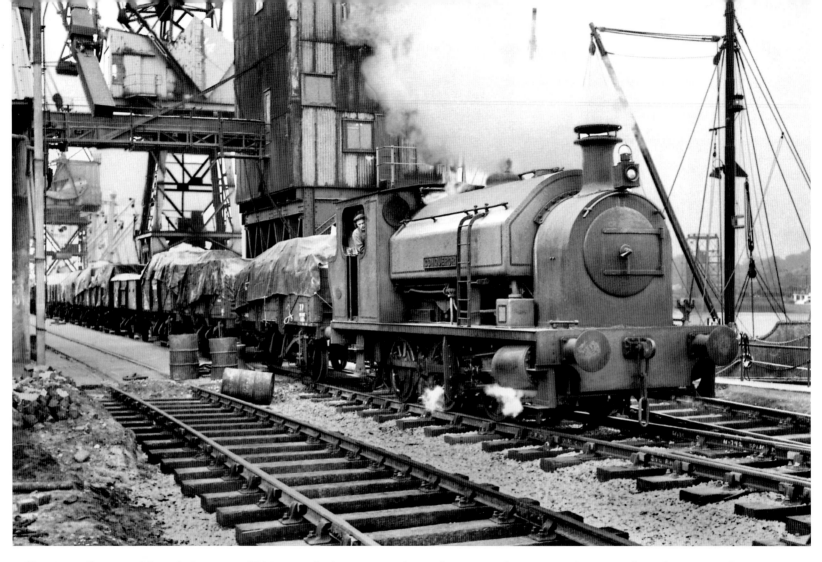

William Bagnall 0-6-0 saddle tank *Conqueror* (W/No. 2893 built in 1945) with mixed wagons at the port's South Quay in the mid-1960s. Spark arrestors were fitted to most Bagnalls at the port as the dock dealt with wood pulp and timber, the most likely cargo to be found in these sheeted wagons. (Author's collection)

# 3

# MERSEYSIDE
# MISCELLANY

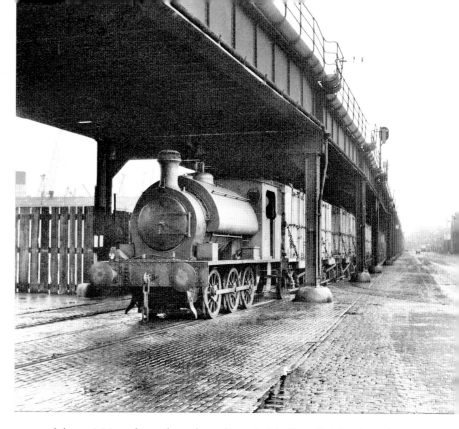

The Port of Liverpool under the Mersey Docks & Harbour Board (MD&HB) stretched for some 7½ miles along the east bank of the River Mersey, comprising thirty-five docks which had been progressively established between 1715 and 1927. At its height the MD&HB railway system comprised 104 miles of track, with exchange sidings connecting with the main line companies, as well as connecting with other private sidings and works. The double-track MD&HB 'main line' ran the length of the port's perimeter along the west side of the dock road, from Gladstone Dock at its northern periphery to Herculaneum Dock in the south, in places un-segregated from the road traffic. A 1904 agreement saw all railway traffic between the quaysides and main line exchange sidings being exclusively administered and handled by the MD&HB's railway. Its standardised loco fleet amounted to almost forty six-coupled steam locos, twenty-six of the Avonside 'B3' and four of the B2 class, but some also came from Hunslet, and a Barclay fireless was employed at the Dingle Oil Jetty; its sister fireless had in fact been destroyed during an air raid around 1941, and many more locos had been sold on over the years. The locos were widely dispersed and were maintained at Gladstone Dock (where the railway's Engineering Department was located), and at Canada, Huskisson, Princes, Hornby and Brunswick Docks. The dockside railway infrastructure tended to be securely concealed behind high walls and fences, but at least the elevated 7-mile-long Liverpool Overhead Railway afforded passengers a 'grandstand' view of

many of the activities taking place along the quayside. Part-dieselisation of the steam fleet came in the late 1950s with twelve six-coupled Hudswell Clarke locos (*see page 37*) delivered between 1958 and 1966 to augment two older Hunslet diesels and to replace all but a handful of the steam locos, but increasingly diminishing rail traffic through the 1960s saw the MD&HB railway system eventually close during 1973, some of its relatively new locos being sold on for use elsewhere. During arguably happier times (*above*), MD&HB inside-cylinder Hunslet 0-6-0 saddle tank No. 8 (W/No. 1828 of 1937) is seen working beneath the Liverpool Overhead Railway at Canada Dock on 9 August 1958. (Jim Peden – IRS collection)

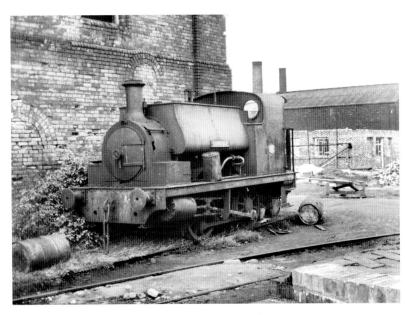

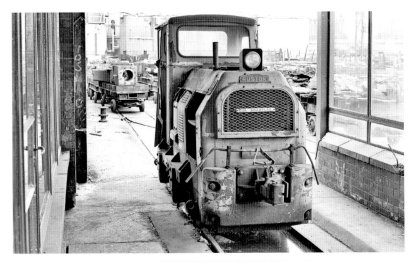

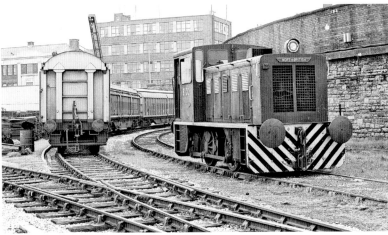

*Above left*: This Robert Stephenson 0-4-0 saddle/piano tank, *Sulphur* (W/No. 2668 of 1889), had originally worked at the ICI Muspratt Works at Widnes until 1950, when it was acquired by nearby Britannia Scrap Metal Co. Ltd. Remarkably, it escaped the cutter's torch and in 1952 was loaned to Joseph Perrin & Son at Birkenhead. By the time of this 31 July 1958 photograph, it had again fallen into disuse. (Peter Eckersley – author's collection)

*Above*: A Ruston & Hornsby 2-foot 6-in. gauge LF class four-wheel diesel-mechanical (W/No. 518493 of 1966) at the Refineries Unit of British Insulated Callenders Cables Ltd (BICC) Metals Ltd's Prescot Works on 11 June 1979. Just thirty-seven of this 48 hp class were built by Rustons. (Kevin Lane)

*Left*: North British 0-4-0 diesel-hydraulic (W/No. 27653 of 1956) at BICC Prescot, Merseyside, on 11 June 1979. (Kevin Lane)

*Opposite page*: Baguley/McEwan Pratt & Co. 0-4-0 petrol-mechanical (W/No. 680 of 1916) at W. & R. Jacob & Co. Ltd's biscuit factory in Long Lane, Fazakerley, near Aintree on 17 February 1968. It entered preservation at the Dinting Railway Centre shortly after this and is now to be found on the private Statfold Barn Railway in Staffordshire. (Bernard Roberts – IRS collection)

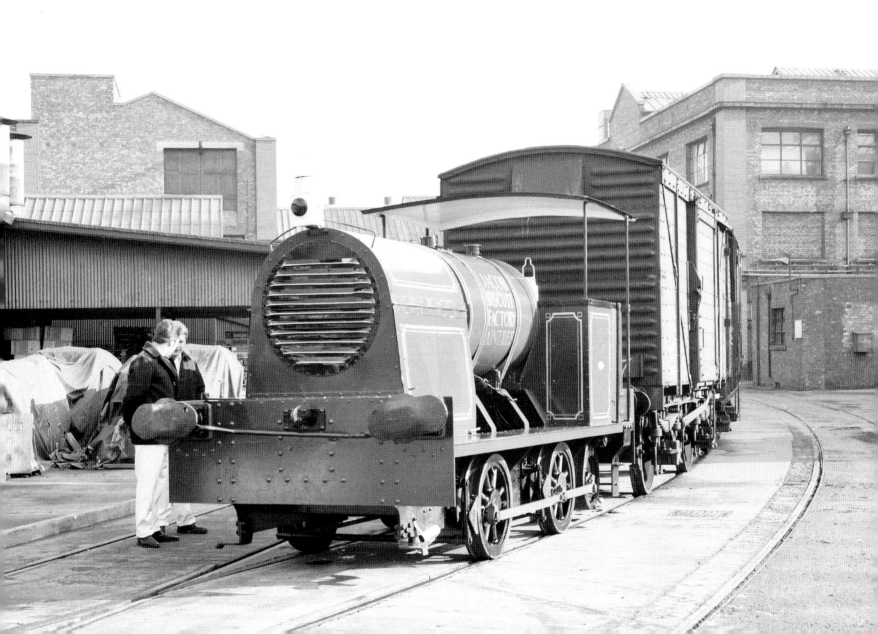

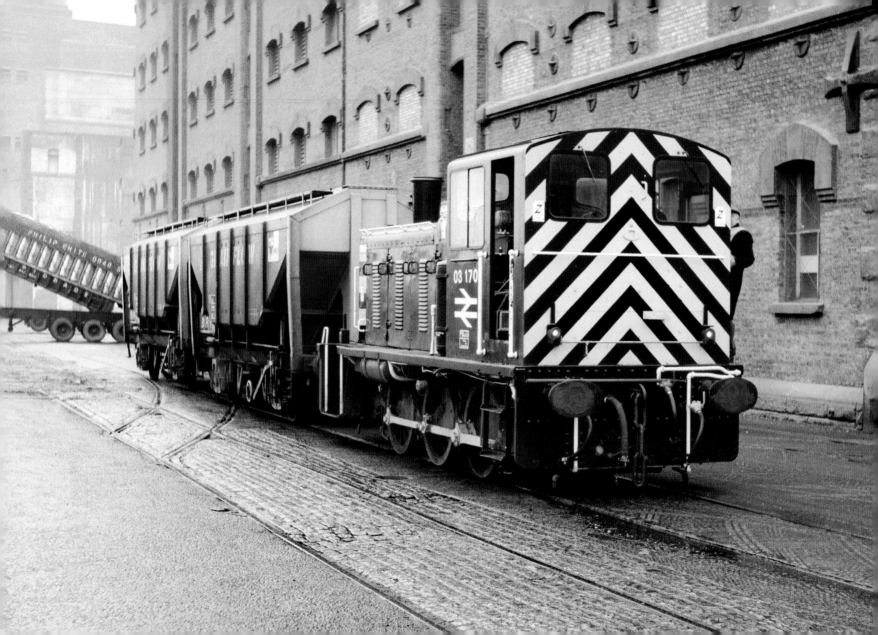

*Opposite page*: On a cold January morning the overnight Speedlink service from Whitemoor Yard in Cambridgeshire to Birkenhead Docks has just two grain wagons for the Spillers Home Pride Mill on Wallasey Dock Road in the Birkenhead Dock complex. On 20 January 1987 BR No. 03170 is seen after rounding the wagons and placing the two 'PAA' Grainflow covered hoppers operated by Traffic Services Ltd for unloading. Seasonal grain traffic was one of the biggest casualties on the demise of the Speedlink BR wagon load network, with numerous line closures in East Anglia and North East Scotland. BR dropped the wagonload network on 8 July 1991 with the intention of moving to bulk flows only and involving little intermediate marshalling or the need for feeder and trip services such as this. (Adrian Nicholls)

*Above right*: Former MD&HB 260 hp Hudswell Clarke locos No. 44 and No. 45 (W/Nos D1372 and D1373 of 1966 respectively) were the second of two batches of 0-6-0 diesel-hydraulics totalling eight locos supplied by Hudswell Clarke to the Board in 1962 and 1966, fitted with roller bearings and 'spark-proof', hence their use at the petroleum installation. On 23 March 1976, they are standing at the Dingle Wharf of Esso Petroleum, on the south side of the Herculaneum Dock by the River Mersey. No. 45 survived and is now preserved on the East Somerset Railway. The dock was located at the south end of the Liverpool Dock system and had been connected to the Liverpool Overhead Railway until its closure in 1956. The tank farm was reclaimed for development into the Liverpool Garden Festival of 1984 and the Herculaneum Dock and surrounding area was developed from 2004 into the riverside Liverpool City Quay residential property development. (Roy Burt)

*Below right*: Yorkshire Engine Co. 0-4-0 diesel-hydraulic *Nina* (W/No. 2862 of 1962) at the Hutchinson Estate & Dock Co. Ltd at Widnes Harbour on 23 March 1976. Opened in 1864, the Estate system comprised over 12 miles of track serving various companies and employed three B3 class Avonside locos like those used on the MD&HB, handling fertilisers, stone, sand, coal, chemicals, cement and asbestos products. *Lucy*, now preserved on the Ribble Steam Railway, was the last to survive, until January 1971. Estate rail traffic ceased around 1977 and the site has now been re-developed and is used by several road-based logistics companies. (Roy Burt)

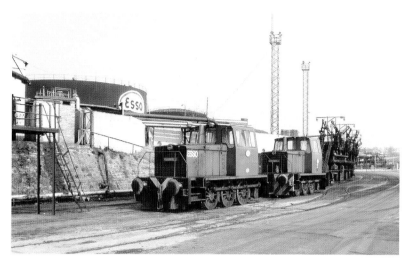

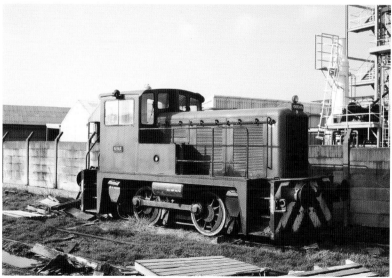

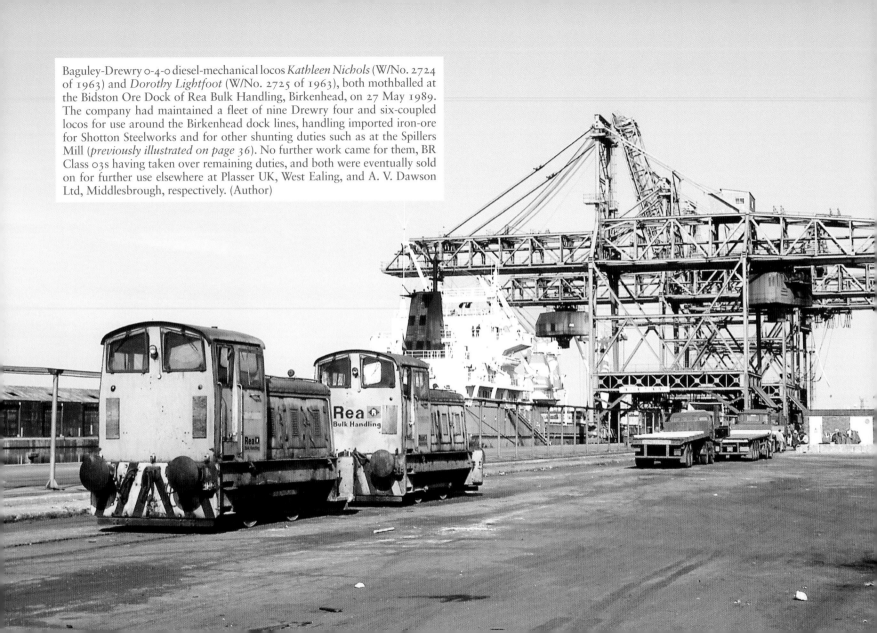

Baguley-Drewry 0-4-0 diesel-mechanical locos *Kathleen Nichols* (W/No. 2724 of 1963) and *Dorothy Lightfoot* (W/No. 2725 of 1963), both mothballed at the Bidston Ore Dock of Rea Bulk Handling, Birkenhead, on 27 May 1989. The company had maintained a fleet of nine Drewry four and six-coupled locos for use around the Birkenhead dock lines, handling imported iron-ore for Shotton Steelworks and for other shunting duties such as at the Spillers Mill (*previously illustrated on page 36*). No further work came for them, BR Class 03s having taken over remaining duties, and both were eventually sold on for further use elsewhere at Plasser UK, West Ealing, and A. V. Dawson Ltd, Middlesbrough, respectively. (Author)

# 4

# SCRAP, STEEL AND ENGINEERING

*Above*: *Bella* was the seventeenth Class 44/48HP (predecessor of the '48DS') Ruston & Hornsby locomotive built, constructed at Boultham Works, Lincoln, completed in July 1937 (W/No. 186309), one of a long line of 351 locomotives of this design built between 1936 and 1967. The fact that this diminutive type of loco was built over three decades is testament to the robustness of the original design. The original 44/48HP design had a Ruston 4VRO diesel engine and weighed 7.5 tons. When photographed at the Vernon & Roberts Stalybridge scrapyard on 6 September 1988, *Bella* was the oldest remaining survivor of this loco type. It had been supplied new to British Acheson Electrodes, Wincobank, in Sheffield in 1937 and was believed to have languished at the Peel Street scrapyard since 1965, but did not pass into preservation. (Author)

*Left*: A former Blackpool Corporation Highways Department John Fowler 0-4-0 diesel-mechanical (W/No. 22598 of 1938) at Pemberton colliery site, then under demolition by contractors Wm. Todd, on 20 July 1984. The colliery had closed as early as November 1946, but was used by the NCB for pumping and as a disposal point. (John Sloane)

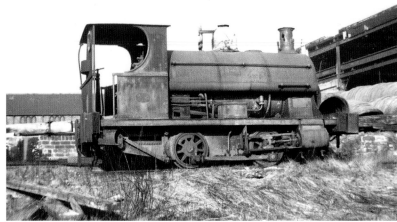

*Left*: An Avonside 0-6-0 saddle tank (W/No. 1600 of 1912), at the scrapyard of Jose K. Holt Ltd, Westhoughton, Greater Manchester, on 3 September 1988, who disposed of many surplus NCB locos. Originally named *Robert*, it had worked at Garswood Hall and Lea Green collieries and was purchased for scrap in June 1965, but was never cut up. It is now privately preserved in Bolton. (Author)

*Above*: Whitecross & Company was founded in 1864, specialising in galvanised wire manufacturing, an industry which came to dominate employment in Warrington in the late nineteenth and early twentieth century. In latter years, the Whitecross works used two pre-owned veteran four-coupled Peckett locomotives. This example, *Baden* (W/No. 830 of 1900), had been supplied new to United Alkali Co. Ltd at Widnes, later becoming part of ICI, but was acquired in 1934 by Whitecross via Warrington loco dealer J. Brierley & Sons. By 28 March 1968, it had clearly seen many years of open-air storage! Donated to the Chasewater Railway in Staffs in 1969, along with the other Whitecross Peckett, it was eventually deemed un-restorable and was sold for scrap. (John Sloane)

*Opposite page*: Peckett 0-4-0 saddle tank *Bold* (W/No. 1737 of 1927) beneath the remains of Ravenhead colliery loco-shed on 7 July 1973. (John Sloane)

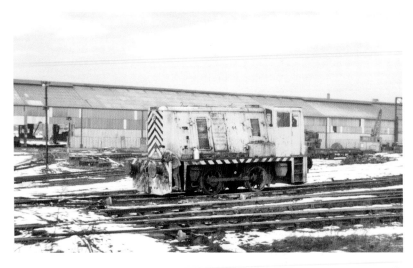

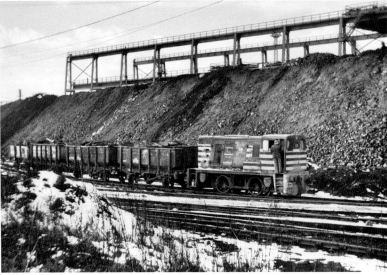

*Left*: Yorkshire Engine Company 0-4-0 diesel-electric No. 38 (W/No. 2616 of 1957) with a slag waste train and (*below left*) No. 44 (W/No. 2704 of 1958) at Irlam Steelworks on 7 March 1970. The Lancashire Steel Manufacturing Company (formerly part of Partington Steel & Iron Co. Ltd until 1930) operated a fleet of eighteen identical 200 hp locomotives, replacing an equally large steam fleet in the early 1950s. As well as a MSCC rail connection, the works also had a wharf on the MSC. Coking coal was brought in from Yorkshire, limestone from Buxton and iron ore imported. In 1957 a new rail connection was built between Irlam station and the steelworks, considerably reducing the MSC Railway's rail traffic. As part of the BSC, it was decided in 1971 to end Irlam's iron and steel production, part of the Corporation's countrywide rationalisation policy, despite being a profitable business. By 1974 only the modern bar and rod mill remained, but this also closed, in 1979. (Both John Sloane)

*Opposite page above left*: Ruston & Hornsby Class LSSH 0-4-0 diesel-hydraulic (W/No. 512843 of 1965), spare to a hired-in BR Class 08, at Ford's Halewood plant on 23 March 1976. (Roy Burt)

*Opposite page above right*: A Ruston & Hornsby four-wheel diesel-mechanical (W/No. 495994 of 1963) at Midland Rollmakers in Crewe on 3 March 1983. The plant came into production in 1951, manufacturing cast iron and steel rolls for the ferrous metal and other metal industries.

*Opposite page below left*: The company had two identical 48DS class Ruston & Hornsby locos and on the same day *Grazebrook* (W/No. 279597 of 1949) stood attached to an internal flat wagon. Both locos had not seen use for some time. Latterly under the ownership of Sheffield Forgemasters, the company went into administration and closed in 2004. (Both Roy Burt)

*Opposite page below right*: 'Sentinel' four-wheel vertical boiler geared tank *Little Enoch* (W/No. 9380 of 1947) dumped out of use at Adamson & Hatchett Ltd, Dukinfield, Cheshire, on 5 July 1969. The firm was established by Daniel Adamson; a founder of the Manchester Ship Canal, in 1842. The plant specialised in heavy engineering products and at the time of this visit was engaged in the fabrication of shipping containers and road semi-trailers. (John Sloane)

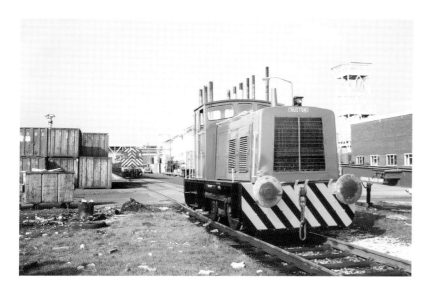

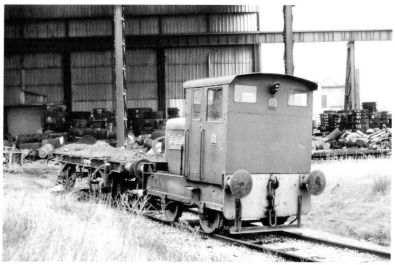

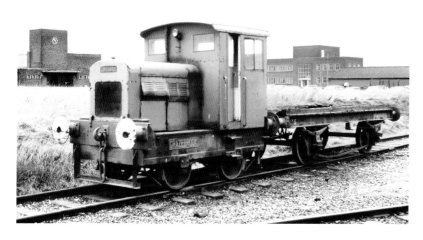

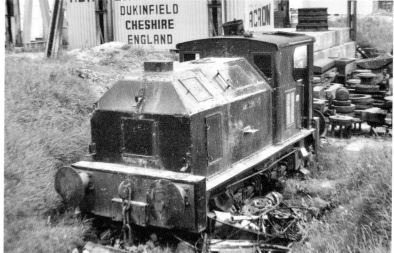

*Right*: John Fowler & Co. (Leeds) Ltd, well known for the manufacture of stationary, ploughing and traction engines, built their first internal combustion locomotive in 1923, a 35 hp four-coupled petrol-mechanical supplied to Nelson Corporation Gasworks. Various models of their basic initial design were produced until the outbreak of the Second World War, predominantly using engines supplied by overseas manufacturers. This John Fowler 0-4-0 diesel-mechanical (W/No. 19645 of 1932) was a rare early centre-cab example, a design later to be produced in large numbers but with shorter bonnets. Fitted with a MAN diesel engine and the first Fowler loco to be rated at 100 hp, it was photographed at Britannia Scrap Ltd at Widnes on 22 August 1960. It was supplied new to Roads Reconstruction Ltd and worked at Sandford, New Vobster and New Frome Quarries in Somerset with allegedly little success, before being sold on to ICI Winnington in Cheshire via a Birmingham dealer in 1946. (Peter Eckersley – author's collection)

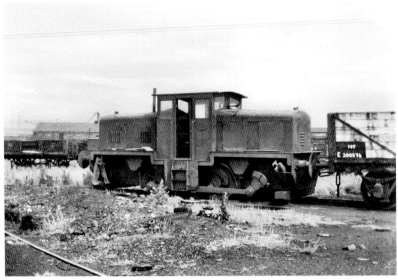

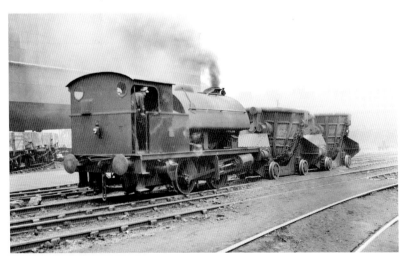

*Left*: The Lancashire Steel Corporation Ltd at Irlam on 21 August 1955, at the time of the mid-1950s mass influx of Yorkshire Engine diesel-electric locos, with a Robert Stephenson & Hawthorns 0-4-0 saddle tank (W/No. 7808 of 1954), itself barely one year old, in charge of two slag ladle wagons. (C. A. Appleton – IRS collection)

*Opposite page*: The copper and smelting works of McKechnie Brothers Ltd in Widnes had two four-coupled Barclay and two 100 hp 'Sentinel' four-wheel geared vertical boiler tank locomotives at their works in the 1950s (*as illustrated on page 43 but W/Nos 9381 and 9383 of 1947 and 1948 respectively*). In the late 1950s Andrew Barclay 14-in. cylinder 0-4-0 saddle tank *Efficient* (W/No. 1598 of 1918) rests between duties in the works yard. It spent its entire commercial career at the Widnes works and was purchased for preservation in July 1969. She was the first steam locomotive to enter the Steamport Southport Museum and was regularly steamed there, but her last public steaming was at the Shelton Steelworks closing ceremony in April 2000, today being found on static display at the Ribble Steam Railway. (Author's collection)

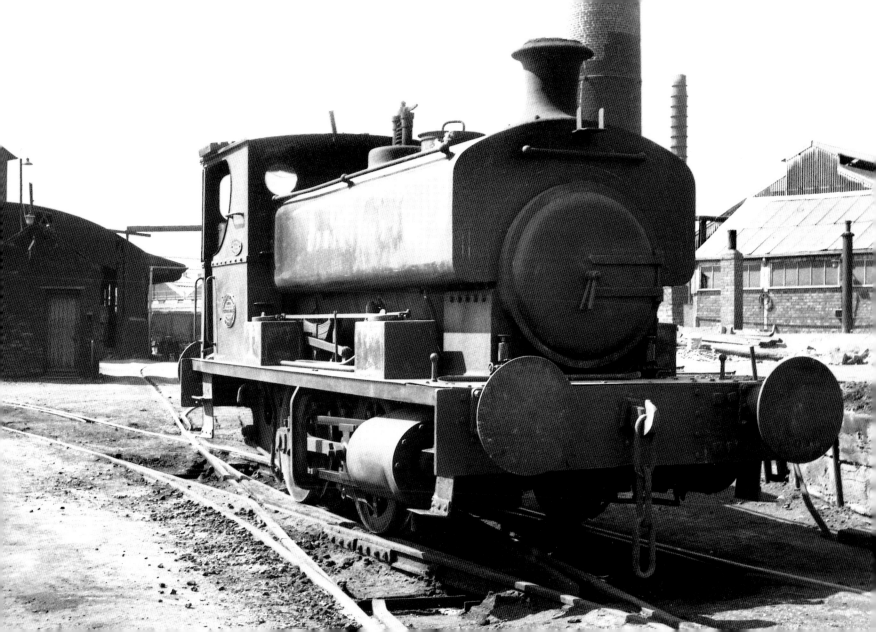

# 5

# EXTENDED SERVICE – LIFE AFTER THE MAIN LINE

*Left*: Former Lancashire & Yorkshire and BR Aspinall 0-4-0 saddle tank No. 51218 shuffles along the sidings adjacent to the Manchester Ship Canal at Trafford Park, having worked a brake van tour of the MSC Railway between Trafford Wharf, Irlam and the M6 overbridge near Latchford on 14 September 1969. Between April 1967 and January 1969, the 'Pug' had been placed on temporary loan to Brown & Polson's (CPC) Trafford Park works (*see pages 15 to 17*) from the Keighley & Worth Valley Railway to deputise for their Barclay 0-4-0 saddle tank, unavailable due to necessary heavy repair work, including boiler re-tubing. The company had traditionally hired such locos from BR whenever their loco was unavailable. (Author's collection)

*Opposite page top left*: One of the two BR Class 05 Hunslet 0-6-0 diesel-mechanical locomotives sold in December 1967 and rebuilt by Hunslet for the CEGB. Former D2587 and D2595 were rebuilt and D2593 was used for spares. Both saw service at the Chadderton power station until its closure in 1982. This is believed to be what was later to become No. 2, in the 'B' power station exchange sidings, which could suggest it to possibly be the former D2587 according to Industrial Railway Society Records, but much confusion has reigned on their true identities over the years! (John Sloane)

*Opposite page below left*: The two shunters employed on the last vestiges of the once vast Trafford Park Estate Railway, photographed on 5 April 1991, were ex-BR No. 08423 and Yorkshire Engine 'Janus' 440 hp 0-6-0 diesel-electric *R. A. Lawday* (W/No. 2878 of 1963), stabled between duties adjacent to the Cerestar works, one of their regular duties at this time, as well as moving wagons of scrap destined for Allied Steel & Wire at Cardiff from the Norton Metals scrapyard on Mellors Road. (Author)

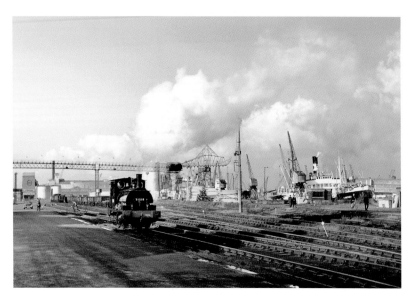

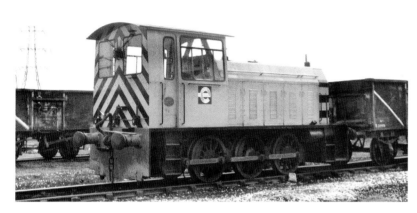

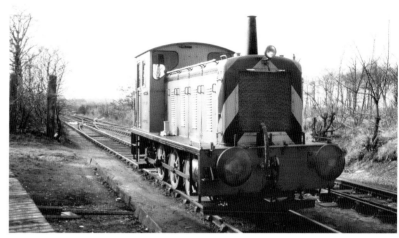

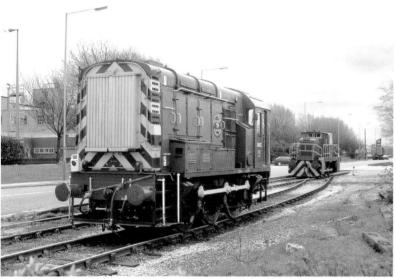

*Above*: The City of Liverpool's Kirkby Industrial Estate had two Drewry 0-6-0 diesel-mechanical shunters, identical in every respect and built on the same Vulcan Foundry production line alongside BR's D2209 and D2210, therefore tenuously deserving of a place in this chapter! On 23 March 1976, No. 4 (Drewry W/No. 2506 and Vulcan Foundry W/No. D241 of 1954) stands on the branch connection with BR. Akin to their main line cousins, the two Drewrys at Kirkby were disposed of shortly after this, their valuable Gardner engines recovered for use overseas and their remains cut up. The Kirkby Estate was originally a Royal Ordnance Factory in the 1940s with six Fowlers (*see page 88*) and four six-coupled saddle tanks, subsequently being handed over in 1946 to Liverpool Corporation for development as an industrial estate. This bordered a region designated as an area for re-housing victims who had lost their homes during wartime air raids. Over 27,000 people had found employment by 1959 on the 380-hectare site supporting a large diversity of manufacturers. In the mid-1950s former Liverpool Corporation trams were stored on the Estate lines awaiting disposal. (Roy Burt)

*Right*: Former Lancashire & Yorkshire Railway Barton Wright (L&YR) 0-4-4 tanks Nos 910 and 613, fitted with 20-foot extended chimneys, at Blackpool Central station in the early 1960s. No. 613 was withdrawn from main line service as early as November 1909 and survived in use as a stationary boiler until November 1964, quite possibly the longest serving stationary boiler in Britain. Blackpool North station also had two ex-L&YR Barton Wright 0-4-4 tanks similarly employed and many others found similar use at Accrington, Cheetham Hill, Colne, Irlam, Queen's Road Manchester, Red Bank and Southport. The Barton Wright tanks were withdrawn well before they were life-expired, superseded on the main line by Aspinall 2-4-2 radial tanks understood at the time to be more suitable for suburban passenger workings. Two Barton Wright 0-6-2 tanks were also sited as stationary boilers at Garston Docks for heating banana vans prior to transit on the main line. (Author's collection)

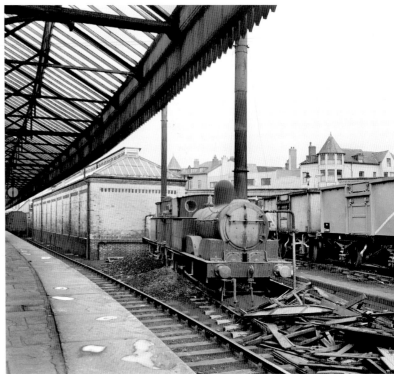

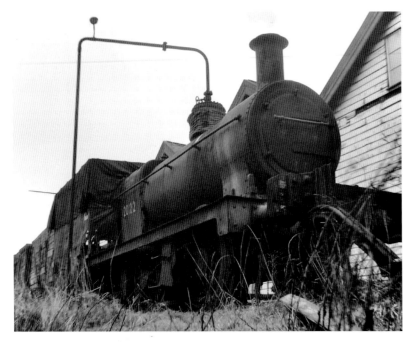

*Left*: Following its withdrawal from BR Lostock Hall motive power depot in March 1965, former 'Jinty' 0-6-0 tank No. 47564 found its way to Manchester and was employed as a stationary boiler at Collyhurst carriage sidings for a short period of time with its side tanks removed. Numbered 2022, it was photographed there 'in steam' on 12 March 1969, defying the BR steam ban of the time and defiantly remaining there until as late as 1972! (John Sloane)

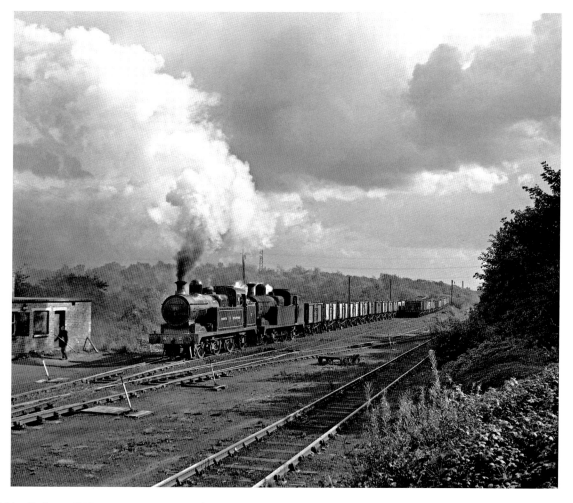

Former North Staffordshire Railway (NSR) 'Knotty' 0-6-2 tanks No. 2 and grubby *King George VI* make a stark contrast between one another as they get to grips, possibly at Sandersons Sidings, with a long loaded train from Sandhole washery, on the extensive NCB Walkden system in 1964. No. 2, bearing the North Staffordshire Railway maroon livery, was already by this time earmarked for preservation. (A. E. Durrant – author's collection)

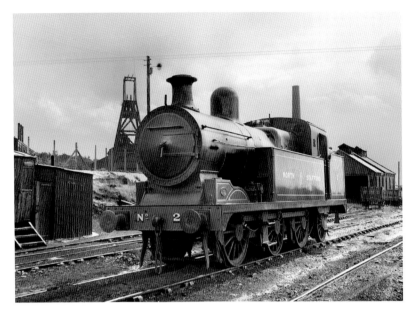

*Left*: Former NSR Railway L class 0-6-2 tank No. 2 at Sandhole in late 1964. Manchester Collieries Ltd (a 1929-registered company) had brought together numerous major collieries west of Manchester. Those operated by the former Bridgewater Collieries Ltd were in the company's 'Central Group' and had an extensive railway system based on Walkden. Several of the Walkden locos in the 1930s were life-expired, replaced by five powerful NSR/LMS superheated 0-6-2 tanks, all delivered under steam between June 1936 and October 1937. Four were allocated to Walkden's shed and spent most of their active lives working together on the steeply graded sections, some parts as steep as 1 in 27, between Astley Green colliery and Linnyshaw Moss exchange sidings. The fifth was allocated to Sandhole shed and worked the heavier trains to Sandersons exchange sidings. They bore lined black livery, and all were named. No. 2 by the time of this photograph was in fact not the original NSR No. 2 (LMS No. 2271, named *Princess* at Walkden), but a rebuild using the frames of *Sir Robert* (NSR No. 72, built at Stoke Works in 1920 and LMS No. 2262), the loco surviving today on the Foxfield Railway. (A. E. Durrant – author's collection)

*Right*: Former LB&SCR/SR Stroudley Class D1 0-4-2 tank No. 2357 *Riddlesdown*, by then named *James Fryers* after the chairman of the Hospital Management Committee, at Grimsargh station of the Whittingham Hospital Railway (WHR) on 14 June 1952. The 'passenger stock' at this time comprised converted ex-LNWR brake vans, replacing worn-out LNWR and L&YR passenger vehicles. WHR services along the line connecting with BR's Longridge branch were operated by Lancashire County Council to serve the Whittingham County Mental Hospital, and were originally in the hands of four-coupled Andrew Barclay locos, eventually being replaced by No. 2357, purchased for £750 from the SR in 1947. Boiler problems with No. 2357 in 1955 resulted in its disposal for scrap and services during the railway's final eighteen months were worked by a 100 hp 'Sentinel' geared vertical boiler tank loco acquired from Bolton Gasworks, namely *Gradwell* (W/No. 9377 of 1947), and like the example featured on page 42. The hospital railway, originally opened in 1889 to carry coal and general provisions as well as passenger traffic, was finally closed in 1957 and the hospital was closed in 1995. (Harry Townley – IRS collection)

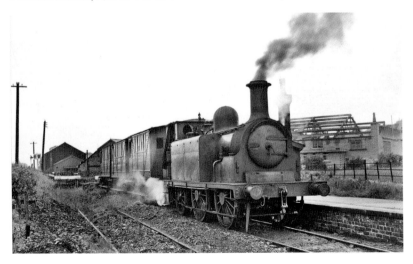

# 6

# NATIONAL COAL
# BOARD COLLIERIES

In 1929 six dominant mining companies in the Manchester area were absorbed to form the Manchester Collieries Ltd. Resultant from the amalgamation of sixteen collieries was the rail connection of the extremely productive Astley Green colliery to the already extensive Bridgewater Collieries railways. Following vesting day, this large system became known as Walkden Railways. Other extensive systems in Lancashire were Standish Railways and Haydock Railways, north and south of Wigan respectively, and Gin Railways near Tyldesley. In the 1950s there were more than sixty active collieries in Lancashire, but by the late 1960s the writing was on the wall for the Lancashire pits, being compared commercially unfavourably by the nationalised industry with the productivity of the Yorkshire mines. Furthermore, BR had been one of the largest customers for coal and the gradual withdrawal of its last steam locos towards August 1968 considerably reduced demand. When Astley Green colliery closed in 1970 the larger railway systems were all history, leaving just a handful of isolated mines still winding coal, the most notable and well-known being at Bickershaw and Bold, due not least to the longevity of regular steam traction into the early part of the 1980s. On a murky October morning in 1962 (*right*) grubby NSR L class 0-6-2 tank No. 2 sets back past a staff bothy on the NCB Walkden system. By this time it had a modified cut-down chimney, the original Adams-design chimney being declared life-expired. Despite its numbering, this was originally NSR No. 72 (LMS No. 2262), and was given the name *Sir Robert* soon after its arrival at Walkden in

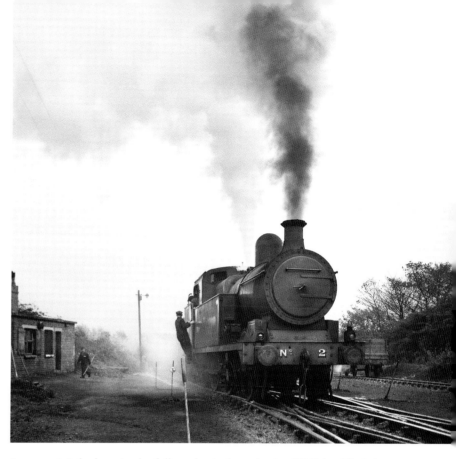

June 1936. It had received a full mechanical overhaul at Walkden Workshops in April 1960, receiving a repaint at Crewe Works, prior to its appearance at Stoke-on-Trent's Golden Jubilee Celebrations masquerading as NSR No. 2. Following a swap of main frames at Walkden Workshops, it emerged as *Sir Robert*, but this time with the actual frames of No. 2, and went on to claim the distinction of being the very last NSR loco to remain in active service, not being withdrawn until October 1967, but scrapped at Walkden Yard in September 1969. (A. E. Durrant – author's collection)

*Right*: Hunslet 0-6-0 saddle tank *Bill* (W/No. 1901 of 1938) at NCB Ince Moss colliery, Ince-in-Makerfield, on 6 June 1959. The colliery was connected to BR via a short branch located just over a mile south-east of Wigan North Western station and also had a connection with a wharf on the Leeds & Liverpool Canal. *Bill* originally worked at Bickershaw colliery, being transferred to Low Hall loco-shed at Platt Bridge during the winter of 1955/56 and on to Ince Moss during the following winter. *Bill*'s service at Ince was again short-lived, for the 16-in. Hunslet was despatched to Walkden Central Workshops in November 1961 and was subsequently scrapped. Ince Moss colliery closed during the latter part of 1962. The colliery site and surrounding area has now, with large-scale reclamation, been transformed into the Wigan Flashes Wetlands, created by natural colonisation because of mining subsidence and the dumping of colliery spoil as well as ash from the now demolished Westwood power station; a legacy of Wigan's industrial past. (Peter Eckersley – author's collection)

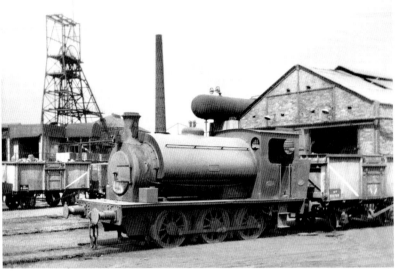

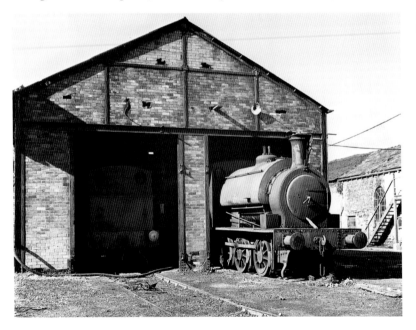

*Left*: By the time of this visit to Ince Moss, the colliery had been closed for two years, but the site remained as an NCB equipment and machinery store. Two locos were found stored at the loco-shed on Saturday 29 August 1964, including Hunslet 0-6-0 saddle tank *Lyon* (W/No. 1809 of 1936) standing outside. It had been transferred to Ince Moss from Parsonage colliery around October 1961 and was eventually scrapped on site in February 1966. Several locos were brought to Ince Moss for storage after the colliery's closure, when there were plans to establish a locomotive workshop there, but this never developed further beyond the early planning stages. (Eric F. Bentley – author's collection)

*Opposite page*: Hunslet Austerity *Warrior* (W/No. 3829 of 1954) with a full head of steam shunting in the falling snow at Walkden on 8 February 1969. (Author's collection)

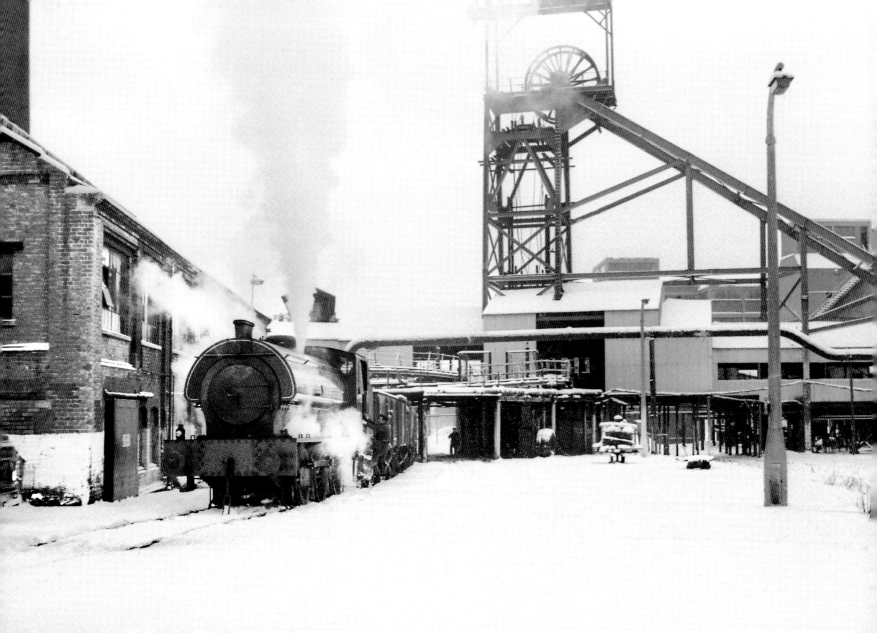

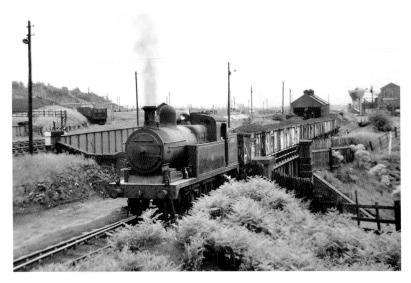

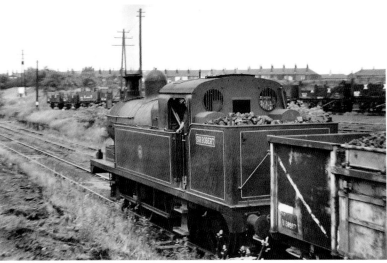

The NCB's Walkden Railways system was the largest and longest-lasting colliery system in Lancashire, founded by the Bridgewater Collieries in 1874. In the latter NCB years, the railway served four collieries, a coal blending plant, many landsale yards, a canal wharf and several waste tips. The NCB area's Central Workshops were also at Walkden, co-located with the running shed. This complex was always referred to as Walkden Yard. The system, before its gradual demise from the early 1960s, also enjoyed the benefit of six connections with the BR network. In the early 1960s, the system's loco-sheds were at Walkden (closed October 1970), Brackley (closed February 1968) and Sandhole (closed September 1968) to the north, and to the south at Astley Green (closed October 1970). By the end of the 1960s, the only section of line in use on the once extensive system was that serving Astley Green, but even that colliery closed on 3 April 1970, with the last trainload of coal from the stockpile being removed on 2 October of that year. After that the Walkden Central Workshops continued in operation as an isolated facility where loco repairs were still undertaken until February 1983, with the workshops closing entirely during 1986. Although the system in its latter years was dominated by mainly Austerity saddle tanks, many fitted with Giesl ejectors to reduce smoke emissions after numerous complaints from residents, the railway was well-known for its quintet of former North Staffordshire Railway Adams-design L class 0-6-2 tanks, originally purchased by the Manchester Collieries Ltd. In fact, the company (and later the NCB) benefited handsomely because of the quest by the LMS for standardisation and to rid its books of these non-standard locos in its fleet, all being disposed of between 1928 and 1937. Five found their way onto duties based from Walkden following their purchase between June 1936 and October 1937 and all survived to pass into NCB ownership on vesting day. Four continued to work into the 1960s. During the final year of working at the washery and on this section of the Walkden Railways system, on 16 June 1966 (*above and below left*) 0-6-2 tank *Sir Robert* leaves Sandhole washery at Wardley (a colliery until September 1962), with a loaded train possibly for Sandersons Sidings. (Both John Sloane)

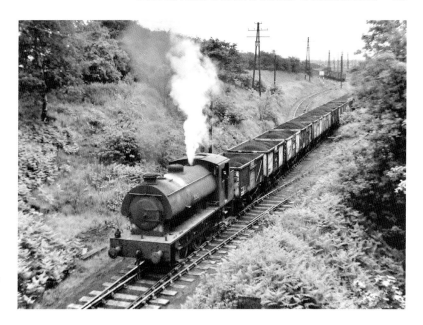

*Above right*: The other locomotive noted at work at Sandhole washery on 16 June 1966 was Hunslet Austerity 0-6-0 saddle tank *Witch* (W/No. 3842 of 1956) with a loaded train, again possibly for Sanderson's Sidings. Obtained new by the NCB, *Witch* spent most of her career at Walkden, apart from a brief spell of duty at Chanters Colliery, Tyldesley, between July 1962 and around the beginning of 1965. After being put through Walkden Workshops, she emerged in around September 1965 and continued in service until around early 1969. She was finally despatched to Maudland Metals Ltd (a dealer specialising in disposing of industrial locos) in Preston for scrap in April 1969. (John Sloane)

*Below right*: As the NCB closed smaller repair facilities in Lancashire, such as at Haydock Central (Haydock Railways), Kirkless (Wigan Coal & Iron Co), Bank Hall and Gin Central, the Walkden Workshops from 1964 became the NCB North Western Division's Central Workshops, servicing no less than thirty-six collieries and depots in Lancashire, Cumberland and North Wales. Latterly it was to take on work from the Staffordshire collieries, and even undertook heavy repairs on two locos from South Wales, Walkden by then having taken on the role of NCB Regional Services in 1967 amidst an ever-shrinking mining industry. The staff at the workshops had the skills to undertake virtually any job required of the NCB's hard-working locos, their experience handed down over generations. Walkden continued repairing locos, even after the closure of the Walkden Railways system, and had an important engineering support role for the Division's collieries, but the Workshops finally succumbed in November 1986 under the custodianship of British Coal. On 16 June 1966, Hunslet 0-4-0 tank *Jessie* (W/No. 1557 of 1927) is seen out of use at the Workshops, a location where several locos from the area's collieries were usually to be found dumped out of use for stripping of parts and eventually for scrap (*see also page 5*). This unusual Hunslet had previously worked at Cleworth Hall colliery, and was retired from Cleworth Hall in September 1961. After languishing at Walkden for over five years, still bearing its nameplates but having lost its worksplates, it was despatched for scrap at Maudland Metals Ltd at Preston in February 1967. (John Sloane)

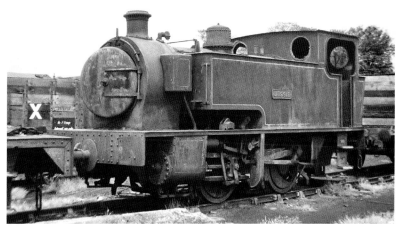

*Right*: Coaling by steam crane at Astley Green colliery on the Walkden system with Hudswell Clarke Austerity 0-6-0 saddle tank *Allen* (W/ No. 1777 of 1944) on 6 March 1968. Astley Green was situated on the north side of the Bridgewater Canal, a few miles east of Leigh. *Allen* was one of a batch of five Austerities purchased from the War Department by Manchester Collieries Ltd in 1946 and spent its entire working career on the Walkden Railways system, working on the Central Railways or at Astley Green colliery. It met its fate shortly after this photograph had been taken, scrapped on site at Astley Green in September 1968. (John Sloane)

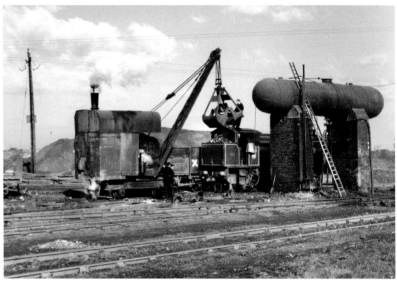

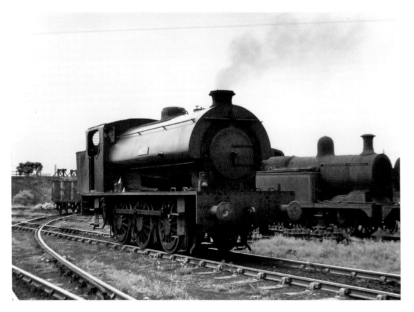

*Left*: Twelve-year-old Hunslet Austerity 0-6-0 saddle tank *Warrior* (W/ No. 3823 of 1954) simmers at Walkden Yard on 16 June 1966 in the company of derelict fifty-three-year-old 0-6-2 tank *King George VI*. The former NSR L class (ex-LMS No. 2257) was built at Stoke Works in 1913, and was cut up at Walkden around this time. *Warrior* had been delivered new to the Walkden Railways and continued in use on the system until October 1970, after which it was occasionally used as the Walkden Yard shunter. It was moved to Bickershaw colliery for further use (*see page 63*) in August 1977, where it was renamed *Fred* in around 1982. Following the demise of steam at Bickershaw, it was acquired for preservation by the Dean Forest Railway in September 1984, where it can still be found today. (John Sloane)

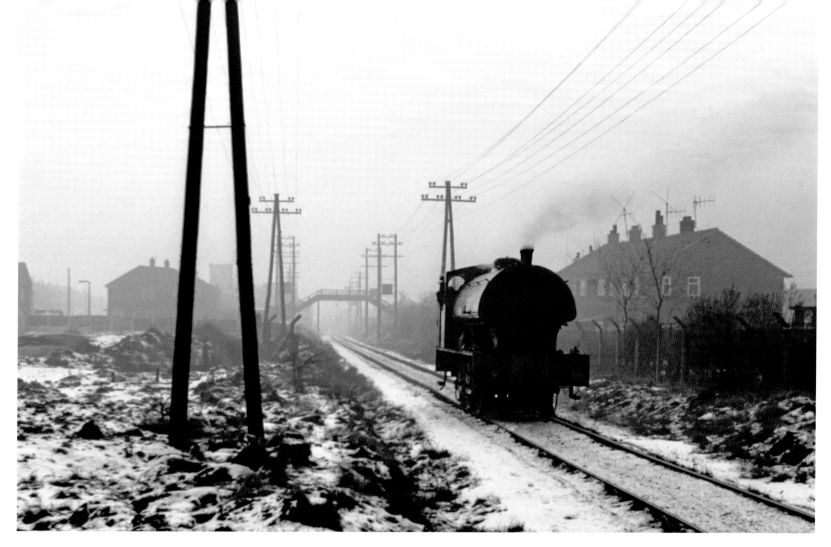

Hunslet Austerity 0-6-0 saddle tank *Respite* (W/No. 3696 of 1950), of Bickershaw fame, trundles light engine along the Walkden bank running line between residential housing on a cold winter's morning in the mid-1960s. It is clear to see why there were complaints from residents and a call for reduced smoke emissions from the NCB Austerity locos following the passing of the Clean Air Act of 1956! (Author's collection)

*Right*: Giesl-fitted Robert Stephenson & Hawthorns Austerity 0-6-0 saddle tank *James* (W/No. 7175 of 1944) is using the main running line as it blasts through Mosley Common colliery, south-west of Walkden, with a rake of empties on Saturday 4 November 1967. Mosley Common, with a connection to the Boothsbank wharf on the Bridgewater Canal to the south and BR exchange sidings at Ellenbrook on the north side, had been extensively modernised by the NCB and was one of Europe's largest and most modern collieries after being converted into a 'super pit' in 1962. Employing 3,000 workers, it was set impossible production targets and had a renowned industrial relations history. Despite its reserves having not been exhausted, the colliery finally closed in 1968, just one year after this photograph was taken. *James* was almost immediately unceremoniously scrapped at Walkden in November 1968 and the colliery site was completely cleared by 1974. (Eric F. Bentley – author's collection)

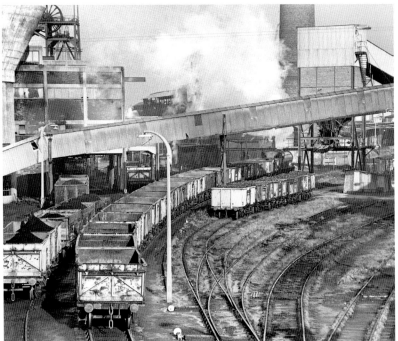

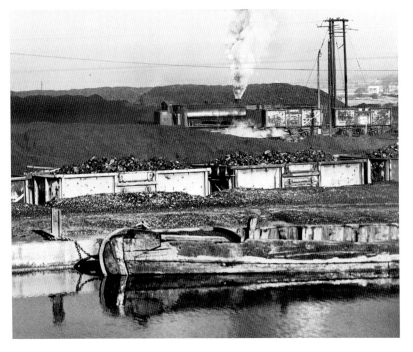

*Left*: A view across the Bridgewater Canal and the remains of a timber-built barge on 4 November 1967, with *James* shunting the Bridgewater Canal's Boothsbank wharf (locally referred to as Boothsbank Basin) on the Walkden Railways system, where coal from nearby Astley Green had been tipped into barges since the system was extended to Boothsbank tip in 1930. Both wide and narrow barges were in use and Astley Green supplied coal to Westwood and Barton power stations. The narrow boats and barges were towed by a powered vessel and had no accommodation. This was three years before the demise of the collieries and railways based on the Walkden Railways. The Austerity saddle tank *James*, which worked at Astley Green between 1947 and 1948 and 1964 and 1967, was to last for one more year on the NCB books and was scrapped at Walkden in November 1968. (Eric F. Bentley – author's collection)

Bickershaw colliery, at Plank Lane, Leigh, was in the industrial heartland of Lancashire, located midway between Leigh and Wigan. The colliery interfaced with BR at Abram sidings, south-east of Wigan, and the spectacle of NCB locos working hard up the fierce gradient on the ¾-mile section to the exchange sidings, sometimes double-headed, attracted photographers from far and wide. At the end of 1975 underground tunnels were completed that connected Bickershaw with nearby Parsonage and Golborne collieries. The output from three collieries was then wound at Bickershaw, ensuring a busy double-shift railway operation there. Before the new order, on 20 September 1974, the colliery was busy but, like so many others, appeared run down. It had an allocation of three Austerity 0-6-0 saddle tanks, of which Hunslet *Hurricane* (W/No. 3830 of 1955) was working (*right*), seen lifting a mixed rake of wagons, dating from different eras, up towards Abram from the washery. Its underfeed stoker and gas producer system (*as seen in the photograph on page 62*) had been removed and its fibre-glass cowl-style 'pork pie' chimney replaced in favour of a conventional chimney. This had been one of the last developments in steam locomotive technology, designed to improve combustion and reduce smoke emissions, but it had limited success due to the demise of steam traction, thus preventing further opportunities for system enhancement. *Hurricane* did not survive for much longer after this and was taken by low-loader to Walkden Central Workshops and was scrapped there in February 1981. The reign of the new General Electric diesel locos *Western Queen* and *Western King* at Bickershaw (*see page 69*) proved to be short-lived; following the miners' strike of 1984/85 an overhead rapid loading bunker was installed. Relaying of the railway line from Abram to the colliery enabled BR traction to assume full responsibility for transporting the loaded MGR wagons directly away from the loader, chiefly to Fiddlers Ferry power station. The NCB diesels were thus rendered redundant and were transferred to Littleton colliery in Staffordshire. At its peak there were in the region of almost forty loaded MGR trains per week from Bickershaw. The colliery was to close on 27 March 1992, thus ending well over a century of mining and associated railway activity there. (Richard Stevens)

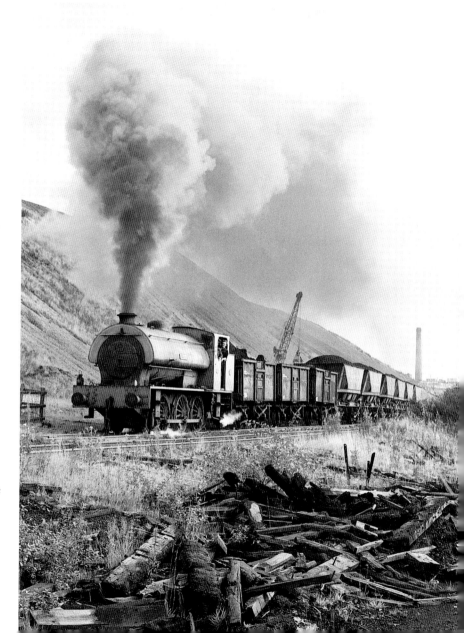

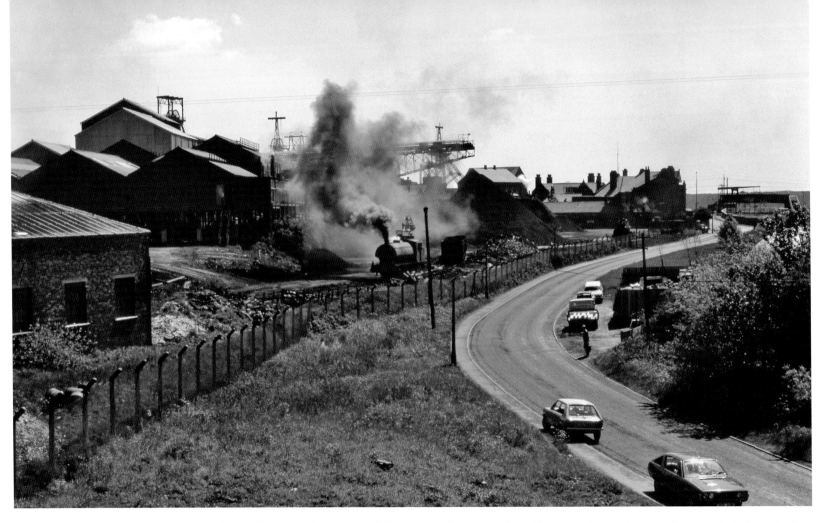

*Above*: Viewed from outside the Bickershaw colliery complex, *Gwyneth* leaves a smoke screen alongside the perimeter fence at the rear of the loco-shed on 26 May 1978.

*Opposite page*: Hunslet *Spitfire* (W/No. 3831 of 1955) is seen climbing out of Bickershaw colliery past the spoil tips towards Abram exchange sidings on 21 June 1972. This Austerity spent its entire career around Leigh, with around four years of service at Parsonage and the remainder at Bickershaw. (Both John Sloane)

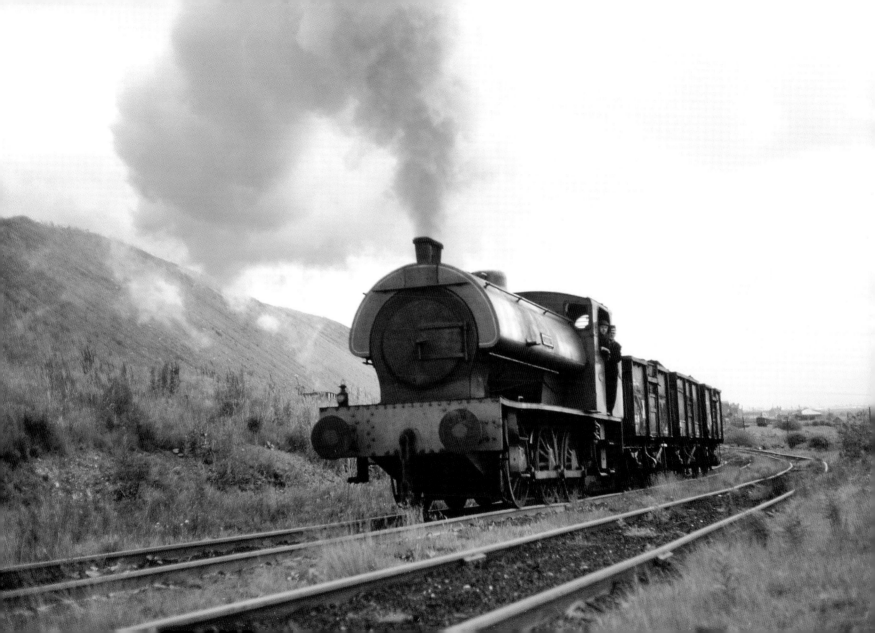

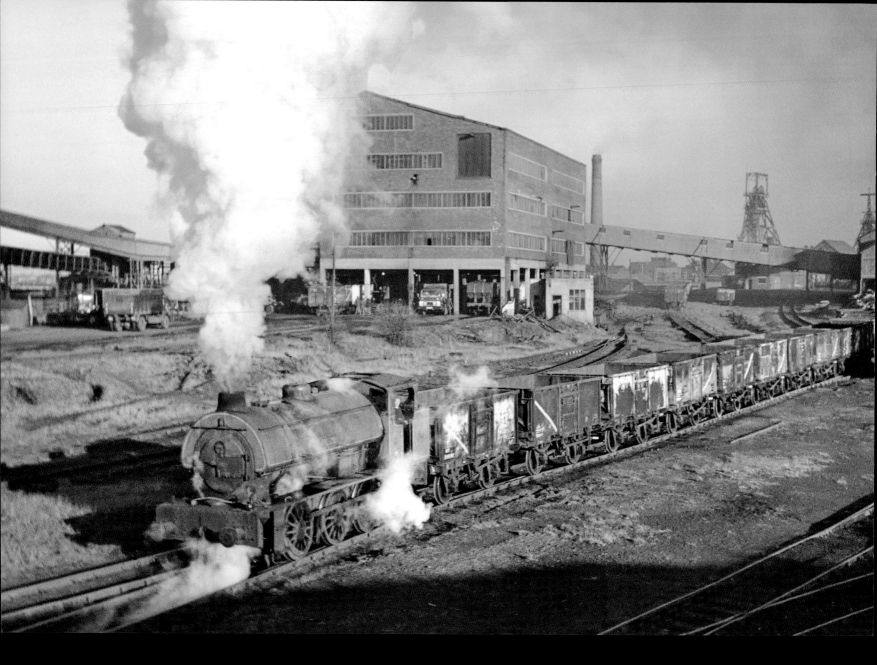

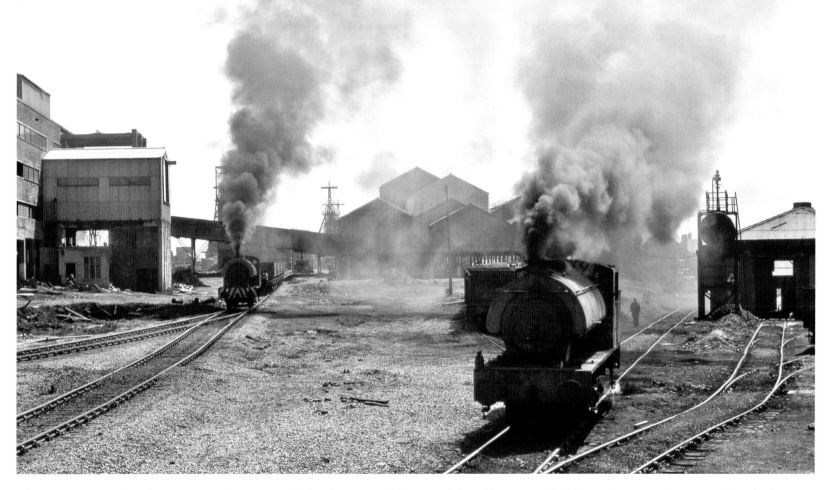

*Above*: Both *Gwyneth* and *Warrior* were in action at Bickershaw on 26 May 1978. The colliery screens had been taken out of use approximately five years before and the through tracks lifted. Upon closure of the Walkden system (*see page 53*), *Warrior* had been transferred in August 1977 to Bickershaw for further use, while *Gwyneth* had seen previous use at Gresford colliery near Wrexham. (John Sloane)

*Opposite page*: Lifetime Leigh area resident *Hurricane* propelling empties uphill towards the coal screens at Bickershaw on 21 March 1972. The Hunslet Austerity was still fitted with its 'pork pie' cowl chimney, but the black exhaust suggests that the underfeed stoker and gas producer system may well have been de-activated! (Richard Stevens)

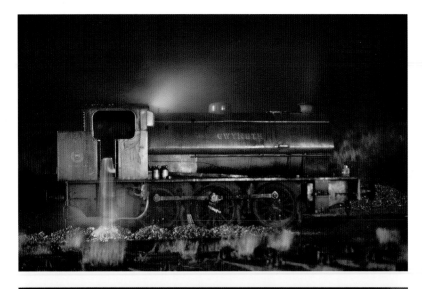

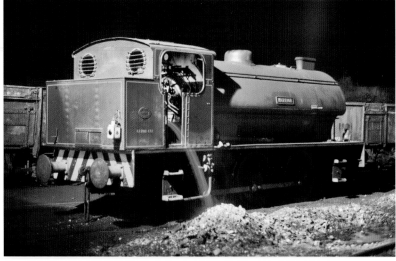

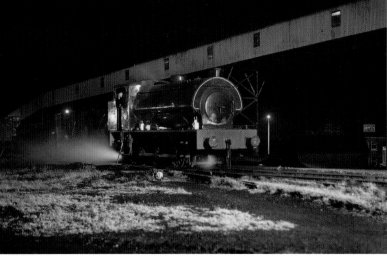

*Above left*: The former Gresford colliery Austerity *Gwyneth* has her fire dropped at Bickershaw on 24 September 1976. Components of this Austerity, such as the boiler and cylinders, were later to be incorporated into the 1985 *Iron Duke* broad-gauge replica locomotive project on behalf of the National Railway Museum. (John Sloane)

*Above*: Hunslet Austerity *Warrior* has its fire thrown out during the evening of 5 October 1977 at Bickershaw colliery. The double-shift system ensured that locos worked until 8.30 p.m. (John Sloane)

*Left*: Giesl-fitted *Respite* in her gleaming signature Walkden maroon livery at Bickershaw on 30 October 1975. (John Sloane)

*Opposite page*: Another evening shed scene, this time on 22 December 1978, with maroon-liveried *Warrior* and green-liveried *Gwyneth* framed in the shed doorway. (Richard Stevens)

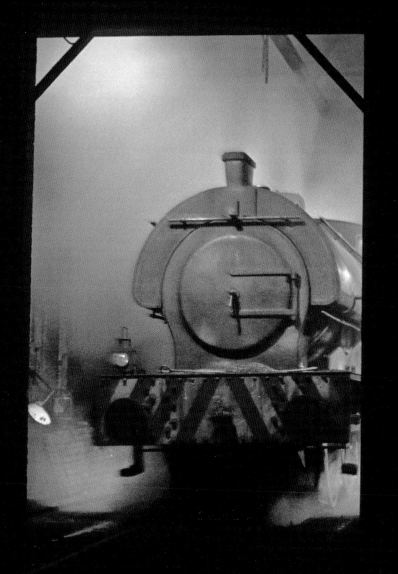
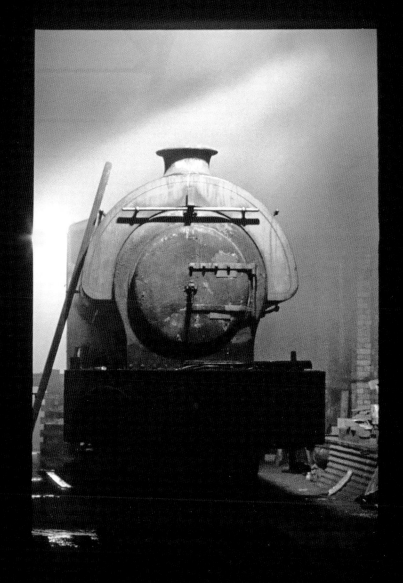

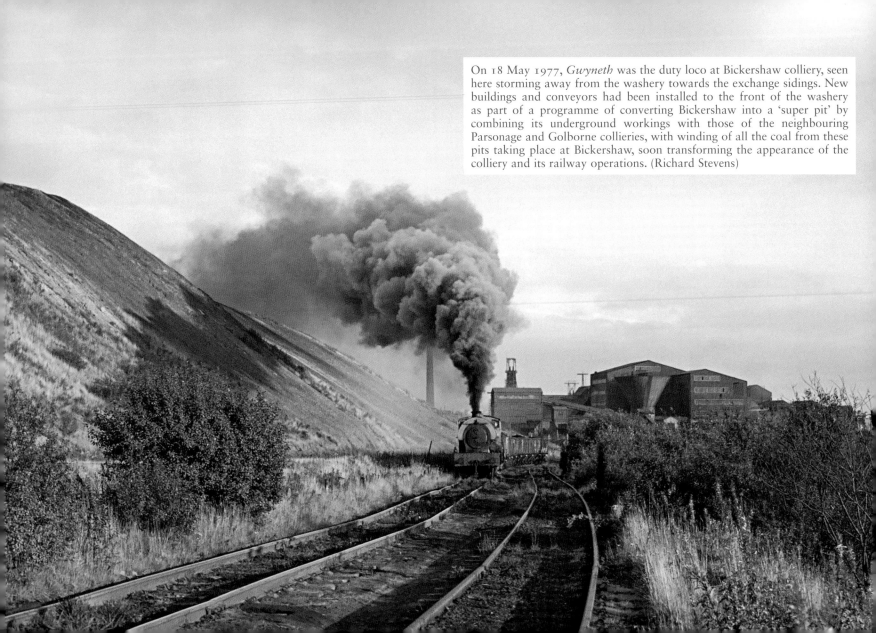

On 18 May 1977, *Gwyneth* was the duty loco at Bickershaw colliery, seen here storming away from the washery towards the exchange sidings. New buildings and conveyors had been installed to the front of the washery as part of a programme of converting Bickershaw into a 'super pit' by combining its underground workings with those of the neighbouring Parsonage and Golborne collieries, with winding of all the coal from these pits taking place at Bickershaw, soon transforming the appearance of the colliery and its railway operations. (Richard Stevens)

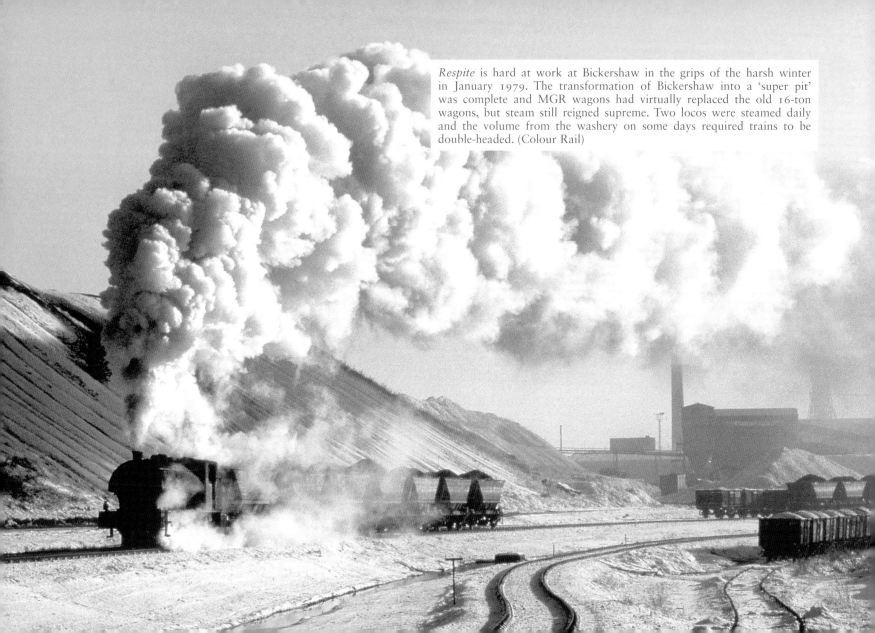

*Respite* is hard at work at Bickershaw in the grips of the harsh winter in January 1979. The transformation of Bickershaw into a 'super pit' was complete and MGR wagons had virtually replaced the old 16-ton wagons, but steam still reigned supreme. Two locos were steamed daily and the volume from the washery on some days required trains to be double-headed. (Colour Rail)

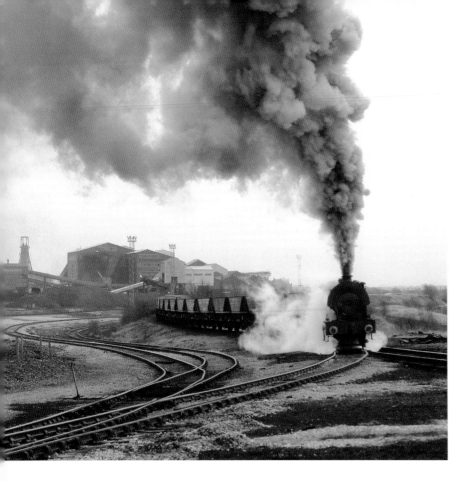

*Left*: A grey day at Bickershaw on 4 February 1983, with a Class 08 diesel on hire from BR due to issues with the NCB diesels, hence the services of standby Hunslet Austerity No. 7 (W/No. 3776 of 1952) being called upon; this was one of the last occasions of steam traction in use, for their days were truly numbered, not just at Bickershaw but within the entire country. The last steam working at Bickershaw was during October 1983.

*Opposite page above left*: The new order at the Bickershaw 'super pit' in the 1980s was new General Electric six-wheel diesel-electric *Western King* (W/No. 5480 of 1979), seen passing Plank Lane tip on 17 April 1980, diesels having arrived during the previous year. *Respite* and *Gwyneth* were disposed of, while *Warrior* and No. 7 were retained for standby duties, in which capacity they operated intermittently until autumn 1983. The colliery was closed in March 1992.

*Opposite page above right*: The transitional period between steam and diesel traction at Bickershaw, with standby loco Hunslet Austerity No. 7 taking on water at the loco-shed standing alongside the General Electric *Western King*.

*Opposite page below left*: Yorkshire Engine 'Janus' 440 hp class 0-6-0 diesel-electric No. 7 (W/No.2749 of 1959) at Parkside colliery, Newton-le-Willows, on 26 May 1980. Parkside, the last deep mine in Lancashire, which had opened as late as 1964, closed in March 1993 without exhausting its coal reserves.

*Opposite page below right*: Parsonage at Leigh was, as well as Bickershaw, a colliery still using its steam winding engine in the 1970s. This 7 February 1975 visit found North British 0-4-0 diesel-hydraulic D5 (W/No. 27876 of 1959) in the colliery yard. This loco was of a similar design to the BR D27xx class, in fact being built on the same production line between D2744 and D2745. This example was permitted to work on BR metals at Parsonage and carried the BTC registration plate 32/1952, presumably transferred at some time from another locomotive in view of its build date! (All John Sloane)

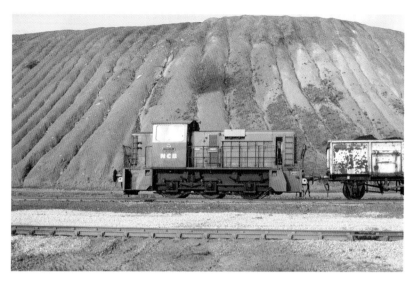

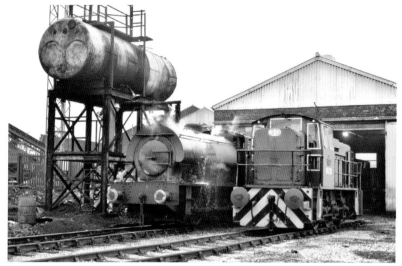

*Right*: A wet 8 December 1978 found immaculate Hudswell Clarke Austerity *Robert* (W/No. 1752 of 1943) hard at work with MGR wagons at the Bold colliery weighbridge area. Bold was a photographically rather uninspiring colliery, adjacent to the main ex-LNWR Manchester–Liverpool line near St Helens. It had been dieselised as early as 1957/58; however, in 1974 the colliery commenced supply of coal to Fiddlers Ferry power station in 48-ton MGR wagons, but the diesel loco was unable to cope on the steep gradient to the exchange sidings on the loads without overheating. Surface Superintendent Harry Simmons, a man with considerable steam experience at other pits, therefore put the spare Austerity saddle tank *Whiston* back to work, an Austerity that had been at Bold since the latter part of 1961 after its transfer from Cronton colliery, mainly in the role of a standby loco for the North British diesel D3. Steam then reigned supreme until shortly after his retirement in 1982, by which time Bold was one of the last industrial locations in the country still using steam on a regular basis. (John Sloane)

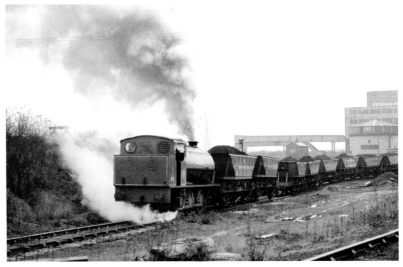

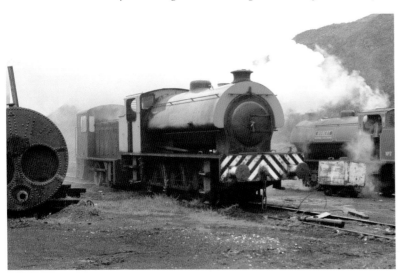

*Left*: With years of waste tip accumulation looming behind in the rain, Hunslet Austerity *Alison* (W/No. 3163 of 1944, rebuilt W/No. 3885 of 1964), Hudswell Clarke Austerity *Robert* (W/No. 1752 of 1943) and North British 0-4-0 diesel-hydraulic D3 (W/No. 27735 of 1958) stand at Bold on 8 December 1978. D3 spent its entire working life there, going for scrap in March 1986. (John Sloane)

*Opposite page*: *Alison* hard at work at Bold on 5 November 1976 with a rake of MGR wagons destined for Fiddlers Ferry. *Alison* was to receive a gender change upon overhaul at Walkden Workshops, returning in February 1980 as *Joseph*! It worked in this guise until rail traffic ceased in 1984, at the start of the protracted miners' strike. Bold never recovered and closed in November 1985, after which both the colliery and power station sites saw rapid clearance and were transformed into an environmental facility known as Colliers' Moss Common. The once stark colliery buildings, coal stockpiles, cooling towers, railway sidings and volcanic Austerity saddle tanks had gone for good, the area now transformed into a tranquil forest with lagoons frequented by voles, lizards and dragonflies. (John Sloane)

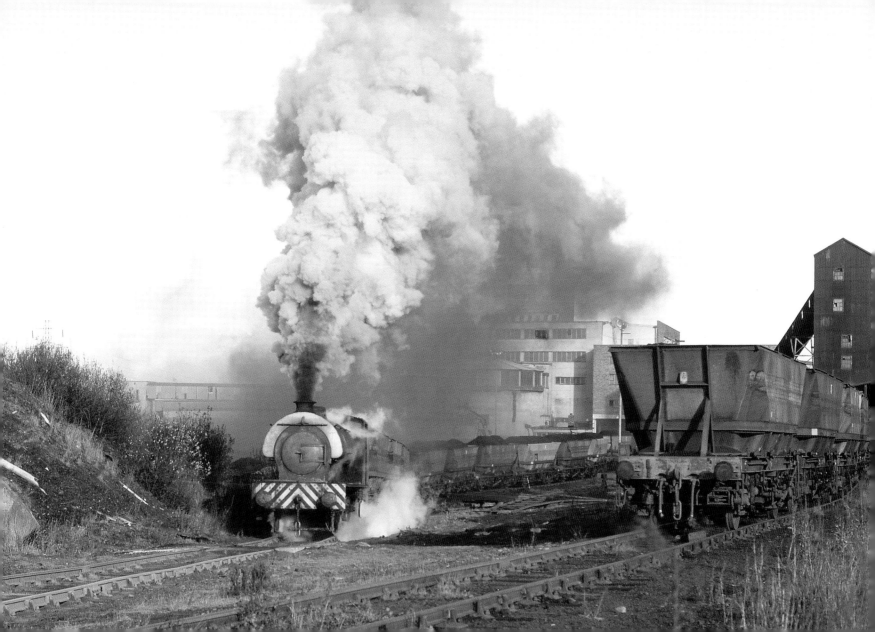

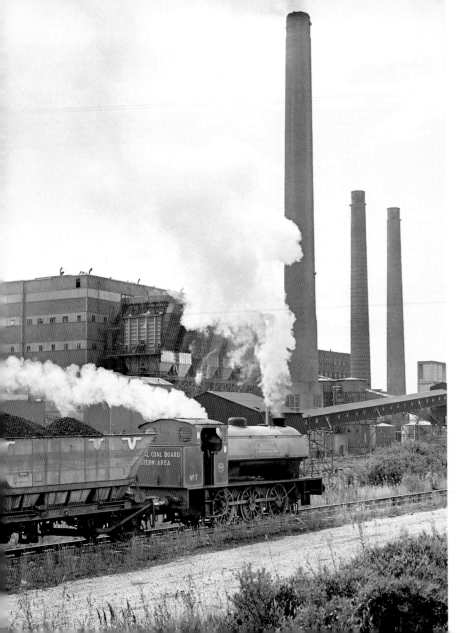

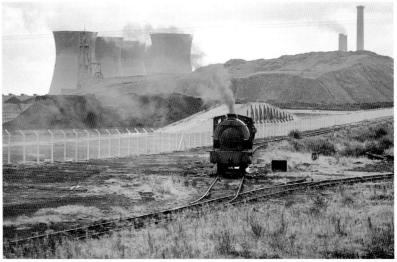

*Left*: Bold colliery, located on the south side of the erstwhile Liverpool & Manchester Railway, near St Helens, was first sunk in 1875. The NCB decided to invest heavily, sinking the shafts deeper, adding a new coal preparation plant and installing an expanded yard layout to cope with the additional volume. A new power station was also built on adjacent land in the mid-1950s, although much of the coal from this very productive colliery was transported to the power station by conveyor. Bold achieved national fame in 'Rocket 150' as its sidings were used as the base for the locos and carriages that participated in the cavalcade through historic Rainhill, just a few miles away. Austerity *Robert* was presented in immaculate condition for the anniversary celebrations of the Liverpool & Manchester Railway, in which it appeared in the parades over the Spring Bank Holiday weekend, alongside historical replicas and main line giants. In summer 1980 *Robert* is shunting MGR wagons alongside Bold power station. (Author's collection)

On 20 September 1974 (*above and opposite page*), Hunslet Austerity *Whiston* (W/No. 3694 of 1950) potters around the eastern end of the colliery, with no MGR wagons in sight. (Richard Stevens)

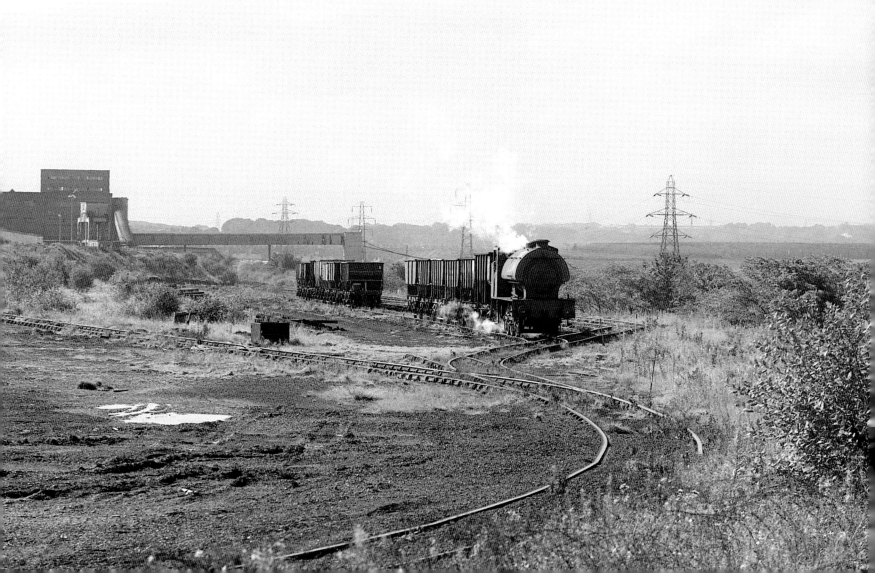

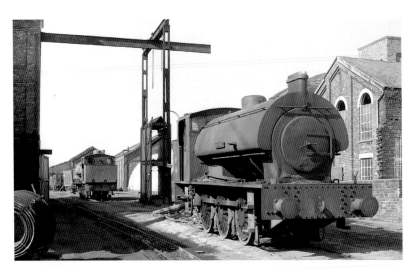

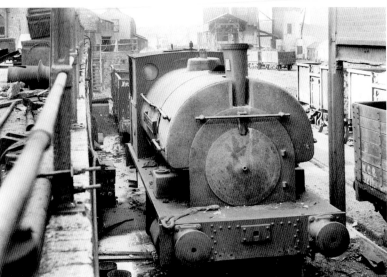

# GIESLS GALORE

*Top left*: On 21 March 1972, diesels had recently taken over operations there, but four Austerity 0-6-0 saddle tanks were still present, two of them standing in the open. Hunslet *Monty* (W/No. 3692 of 1950), in apparently good condition, was scrapped around June 1973, and behind, Hunslet *Robin Hill* (W/No. 3779 of 1952), in not such good order, was scrapped during September 1972. (Richard Stevens)

*Bottom left*: Giesl ejector-fitted W6 class Peckett 0-4-0 saddle tank *Collins Green* (W/No. 1762 of 1933) has been dumped out of use at Ravenhead colliery, St Helens, on 3 April 1965. It was originally named *Bold No. 2* and worked at the colliery of that name with an identical Peckett, both being transferred to Ravenhead colliery in the early 1960s after attention at the Ravenhead Central Workshops. The colliery ceased winding on 18 October 1968, but remained in use as a washery for road-hauled coal for several years thereafter. Two of the colliery's remaining fleet of three four-coupled locos, a similar 'W6' Peckett and a Hudswell Clarke, were scrapped during 1968/69, but *Collins Green* somehow survived on site and was not dealt with there, in a similar vein, until as late as July 1973. (Author's collection)

*Opposite page*: During happier times at Cronton colliery, Giesl-fitted *Monty* is hard at work on a murky 10 December 1968. Cronton colliery, the most westerly in Lancashire, was situated south of Whiston in what is now Merseyside, and was one of the last operational mines in Lancashire, closing in 1984. (Author's collection)

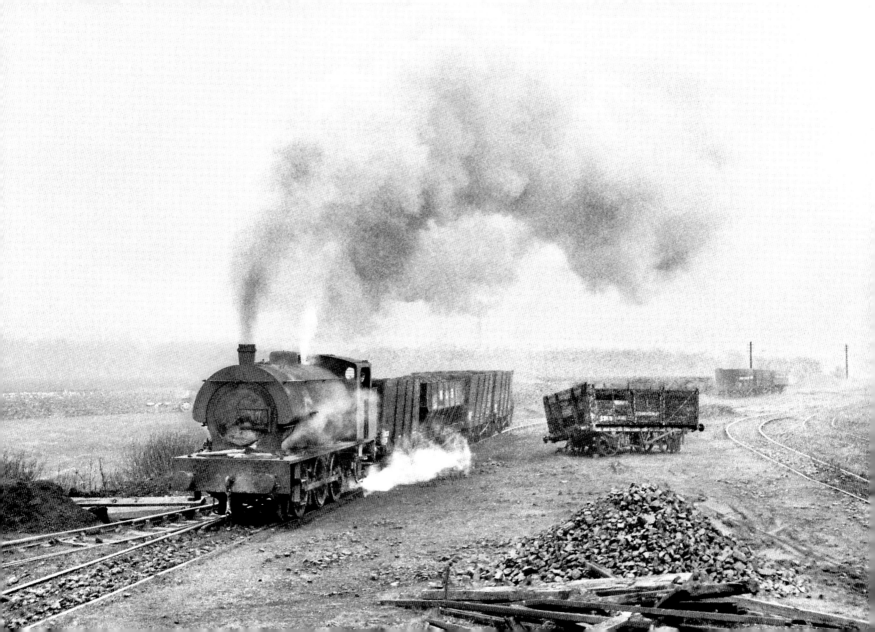

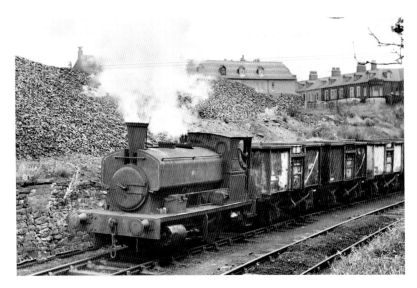

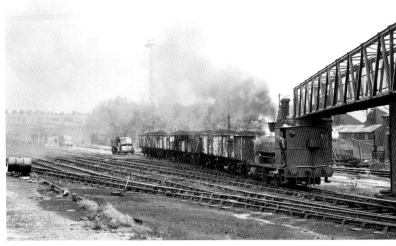

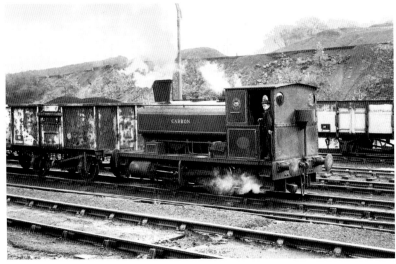

Giesl ejector-fitted four-coupled Andrew Barclays were unusual, but Walkden Workshops treated a brace of them. On 26 June 1968 (*above left*) *King* (W/No. 1448 of 1919) is shunting the exchange sidings for Bank Hall colliery. Bank Hall's other Andrew Barclay 0-4-0 saddle tank, *Carbon* (W/No. 1704 of 1920), was also so equipped and (*above and below left*) is shunting the exchange sidings serving Bank Hall colliery on 17 October 1965, which were connected to BR via a half-mile branch north-east of Burnley station. The colliery also enjoyed a wharf on the Leeds & Liverpool Canal. *Carbon* must have only just been so equipped, having been noted with a standard chimney in September 1964, but its effort to reduce smoke emissions at Burnley didn't appear to be too successful! *Carbon* was scrapped on site in November 1968, but *King* was more fortunate and, upon the colliery's closure in April 1971, saw further work at Haig colliery in Cumbria, following overhaul at Walkden Workshops during late 1971. (All Peter Eckersley – author's collection)

*Opposite page*: As featured earlier at Bickershaw, Hunslet Austerity *Respite* is in full cry on the Walkden system on 30 November 1968. (Author's collection)

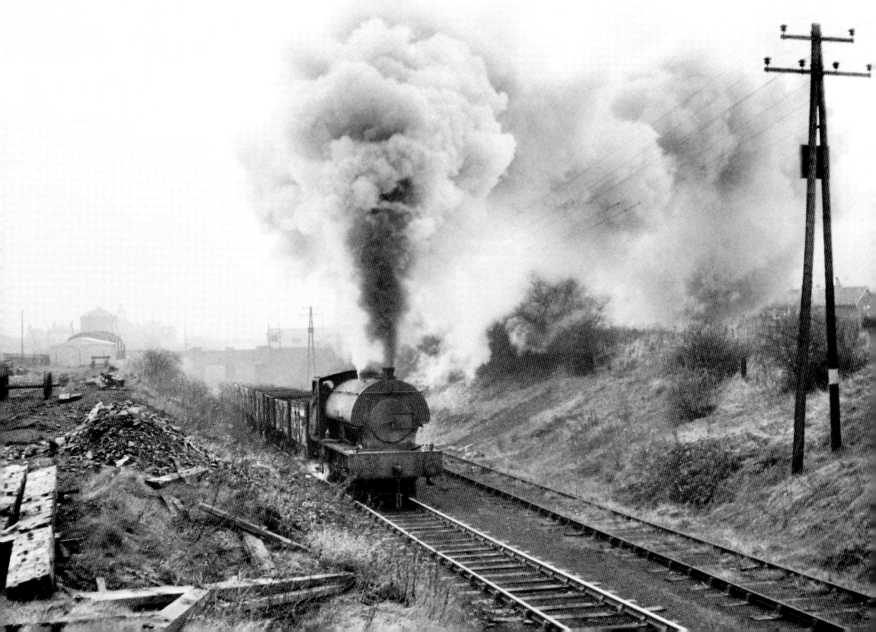

# 8

# NCB VETERANS IN THE NORTH WEST

*Right*: Peckett 0-6-0 saddle tank *King* (W/No.957 of 1902) on shed at Haydock colliery on 11 May 1957. The fine inside-cylinder veteran was truly peripatetic, having previously worked at Garswood Hall and Park collieries before being transferred to Lea Green in spring 1964, then just over one year later to Cronton colliery, where it finally met its fate in November 1968. (Author's collection)

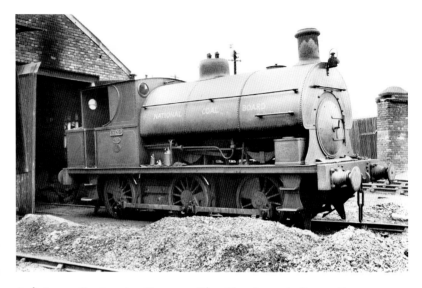

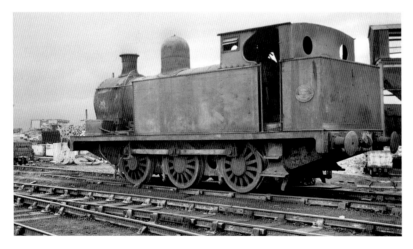

*Left*: Lowca Engineering Company Class D 0-6-0 tank *George Peace* (W/No. 245 of 1906) out of use at Gin Pit, Tyldesley, on 13 January 1957. The West Cumberland works near Whitehaven supplied three six-coupled tank locos to Manchester Collieries Ltd (later NCB Gin Railways from vesting day) between 1899 and 1906. *George Peace* faced the cutter's torch during the following November. Gin Pit had extensive repair facilities, used by various collieries until 1966, and used two eight-coupled tank locos, a rare type in UK industry, only three known examples existing. The railway system ran from a BR connection at Tyldesley through Gin Pit colliery to Nook colliery, with a branch to Bedford colliery, and to Staithes on the Bridgewater Canal. (Author's collection)

*Opposite page*: Robert Stephenson 0-6-0 saddle tank *Imogen* (W/No. 3006 of 1901) at Garswood Hall colliery, Ashton-in-Makerfield, on 11 May 1957, before its transfer to Haydock Railways via the Central Workshops. Supplied new to Garswood Hall Collieries, it survived on the Haydock Railway until its closure, and was scrapped in September 1966. (C.A. Appleton – IRS collection)

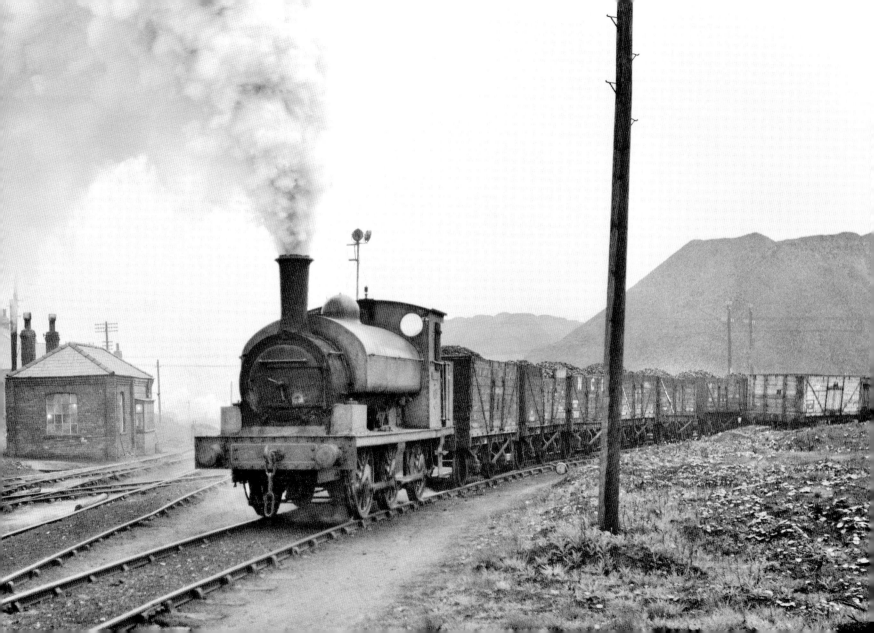

*Right*: Veteran Kerr Stewart 0-6-0 tank *Francis* (W/No.3068 of 1917) at Astley Green colliery, probably in the early 1960s, before the fitment of its unsightly Giesl ejector at Walkden Workshop in 1966, such a move being forced upon Walkden by repercussions following the Clean Air Act of 1956. The 'Victory' class loco served for the Inland Waterways & Docks organisation during the First World War and was later moved to the Railway Operating Division of the Royal Engineers and numbered 603. After hostilities, it was acquired by the Bridgewater Collieries in 1919, taking over the name from their first loco in the fleet, an 1870-built Manning Wardle. A decade later Francis colliery was absorbed into the Manchester Collieries Ltd upon its formation in March 1929, bolstering its already large fleet of over forty widely varied four, six and eight-coupled locos. *Francis* was clearly a popular workhorse for, during its career on the extensive Walkden Railways, it worked on the arduous duties demanded of locos at Mosley Common, Sandhole and finally at Astley Green collieries until as late as 1967, when it was withdrawn and scrapped at Walkden Yard, in October 1968. (Kevin Lane collection)

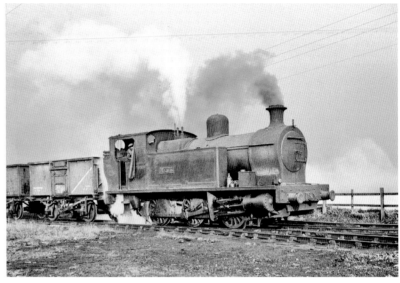

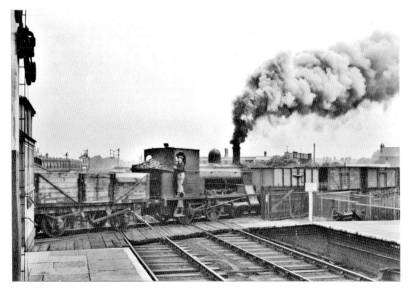

*Left*: Haydock Foundry 0-6-0 well tank No. 5 *Parr* (W/No. 'E' of 1886) crossing the Liverpool & Manchester Railway at Earlestown on the NCB Haydock system on 30 August 1951. It was one of six almost identical locos built between 1869 and 1887, designed by Josiah Evans, son of Richard Evans who owned the Haydock Collieries. The extensive Haydock Collieries Railway comprised around 60 miles of track and demanded powerful locos capable of hauling heavy trains over steep gradients. *Parr* was sent to Haydock Central Workshops in early 1958 and saw further service at Park Colliery, Garswood, where in spring 1958 it joined even older survivor No. 4 *Makerfield* (W/No. 'D' of 1876). It saw further service until finally succumbing and being sold for scrap, along with *Makerfield*, in around April 1963 to Jose K. Holt & Gordon of Chequerbent, a scrap dealer who disposed of many surplus NCB locos from the region *(see page 40)*. *Bellerophon* (W/No. 'C' of 1874), the only survivor of the six, worked at Lea Green colliery into the mid-1960s. It is now in the care of the Vintage Carriages Trust at Ingrow on the Keighley & Worth Valley Railway. (C. A. Appleton – IRS collection)

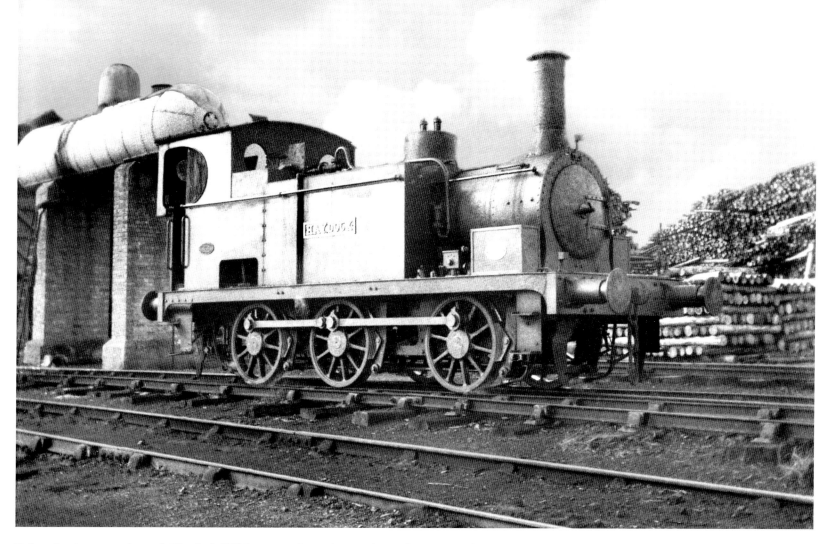

Robert Stephenson 0-6-0 tank *Haydock* (W/No. 2309 of 1876) on 22 September 1958 at the Acton Grange Timber Wharf, located alongside the north bank of the MSC and connected to the MSC Railway system. Transferred to Haydock Railways in 1963, after its withdrawal in 1966 it was preserved at the Penrhyn Castle Railway Museum. (Author's collection)

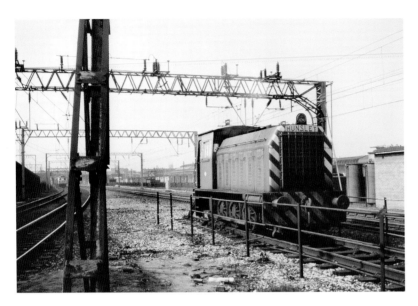

# 9

# COAL CONCENTRATION DEPOTS

*Left*: This Hunslet 0-6-0 diesel-electric (W/No. 4550 of 1955) stands in the headshunt at the Rathbone Road Coal Concentration Depot (CCD) of the Lancashire Fuel Company at Wavertree, Edge Hill, Liverpool, on 23 March 1976. The BR Class 05 was of a visually similar design, being built by Hunslet between 1955 and 1961, but did not have such a long bonnet and was not equipped with a front headlight. (Roy Burt)

*Right*: On 23 March 1976, the other working locomotive at the then recently opened CCD at Rathbone Road near Edge Hill was Ruston & Hornsby 0-4-0 diesel-mechanical *Mars* (W/No. 414299 of 1957), seen at the head of BR 21-ton coal hoppers. The 165DS class Ruston had previously been in the ownership of the East Midlands Gas Board at the Litchurch Gasworks in Derby. BR railway management oversaw the introduction of regional CCDs as a direct result of recommendations from the Beeching Report on the *Reshaping of Britain's Railways* in an effort to bring together the NCB Marketing Department, coal merchants and the railway into a more cohesive distribution supply chain of domestic coal provision. (Roy Burt)

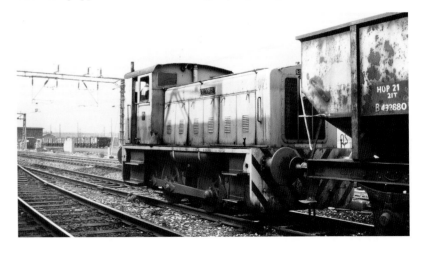

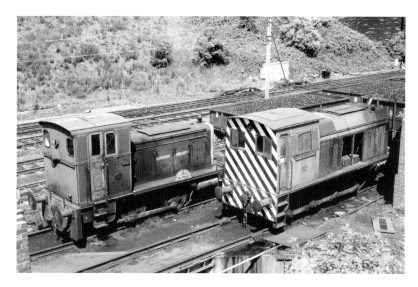

*Right*: Andrew Barclay 0-4-0 diesel-mechanical *Lord Bert* (W/No. 383 of 1951) and a Hunslet 0-6-0 diesel-electric (W/No. 4550 of 1955) alongside the coal drop at Rathbone Road CCD on 29 June 1980. *Lord Bert* originally worked at Lever Brothers at Port Sunlight, where it carried the name *Prince Charles*. The Hunslet had previously worked at Widnes for the United Sulphuric Acid Corporation Ltd's Green Oak works. (John Sloane)

*Left*: The Southport CCD of the Lancashire Fuel Company on 8 February 1975 with Drewry 0-4-0 diesel-mechanical (W/No.2723 of 1961) standing with 21-ton coal hopper wagons alongside the former BR Southport motive power depot, that was later to become the Steamport heritage centre, and was to subsequently close, given over to retail development. The Drewry had previously worked at the Filton CCD of Bristol Mechanised Coal Ltd. Its final move proved to be its downfall for, after its tour of duty at Southport, around late-1984, it was transferred to the company's Rathbone Road depot but was not to survive for too long thereafter and was soon cut up on site at this Liverpool depot. (John Sloane)

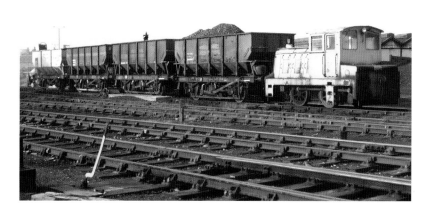

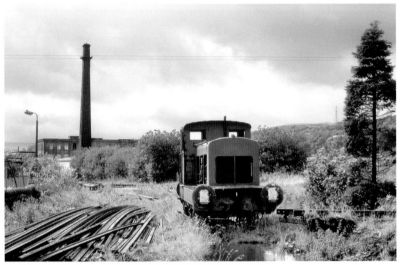

*Left*: The British Fuels Blackburn CCD had two Drewry-built locomotives, but this 1957 vintage machine had fallen into disuse by 3 September 1988. Jointly built by Robert Stephenson & Hawthorns (W/No. 7921) and the Drewry Car Co. (W/No. 2586), this 0-4-0 diesel mechanical loco worked alongside ex-BR Class 04 D2272. (Author)

*Above*: The vacated Rawtenstall yard on 2 September 1988, formerly of the British Fuel Company and adjacent to what is now the East Lancashire Railway; Ruston & Hornsby 88DS class four-wheel diesel-mechanical (W/No. 312432 of 1951) had apparently received some attention, but all proved to be in vain, for it did not survive the scrap man. (Author)

*Opposite page*: The other Drewry locomotive at the British Fuel Company's Blackburn CCD on 3 September 1988 was former BR 1958-built Class 04 D2272. Disposed of by BR in October 1970 from Bradford Hammerton Street depot, it bore the name *Alfie* during its duties at Blackburn, where it positioned bottom-discharge wagons over a conveyor. It survived into preservation and can now be found at Rowsley, Derbyshire, as part of the Heritage Shunters Trust collection. (Author)

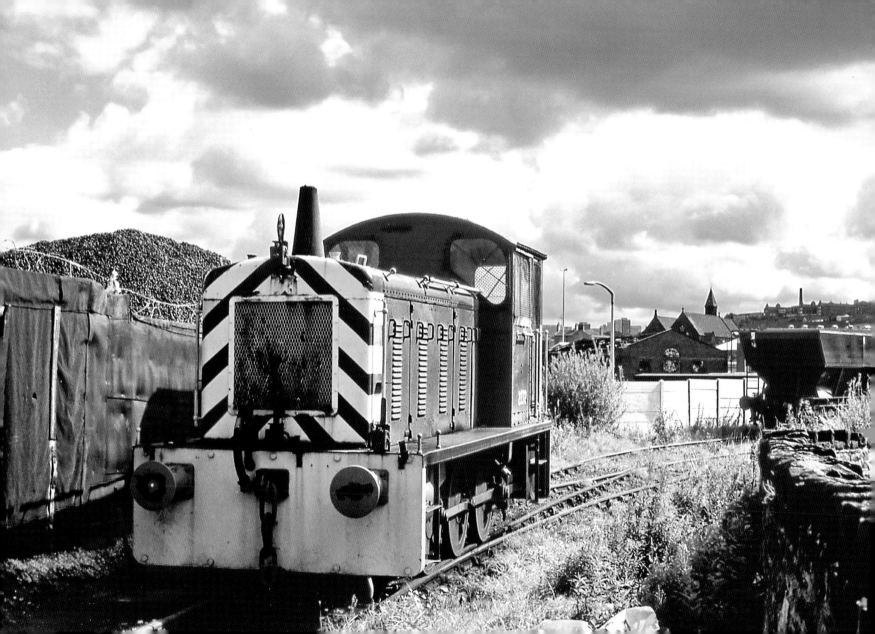

# 10
# ELECTRICITY, GAS, OIL AND CHEMICALS

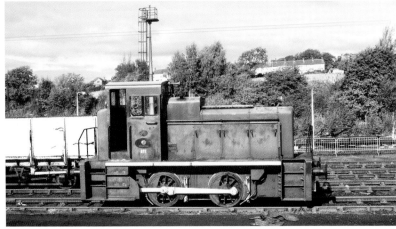

*Left*: CEGB Padiham 'B' power station's Andrew Barclay 0-4-0 diesel-mechanical No. 2 (W/No. 474 of 1961) on 2 September 1988. Padiham 'A' station was commissioned in January 1927. Located by the Burnley–Blackburn railway on the north bank of the River Calder, passenger services were withdrawn in 1957, but part of the line was retained for the coal deliveries. Padiham 'B', commissioned in 1962, was coal-fired throughout its existence and in latter years was rail-fed by coal from Maryport, Cumbria. 'A' station was closed in 1969 and 'B' station ceased generating in March 1993. (Author)

*Above*: Andrew Barclay 0-4-0 diesel-mechanical No. 1 (W/No. 473 of 1961) at National Power's Padiham 'B' power station during its public open day on 8 October 1989. The distinct likeness of this loco to the BR Class 06 will be noted; in fact, the two Padiham Barclays were built directly after the completion of BR's order, their last being D2444 (W/No. 471). (John Sloane)

*Opposite page above left*: Andrew Barclay 0-4-0 diesel-mechanical *Lord Leverhulme* (W/No. 388 of 1953) at the BR exchange sidings serving Lever Brothers' Port Sunlight factory on 22 March 1976. The Barclay survives today and is now a depot shunter at the Southall motive power depot of the West Coast Railway Company, curiously bearing the fictitious BR running number D2447. (Roy Burt)

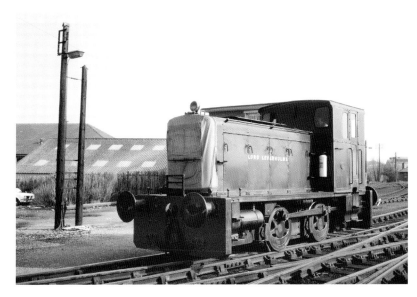

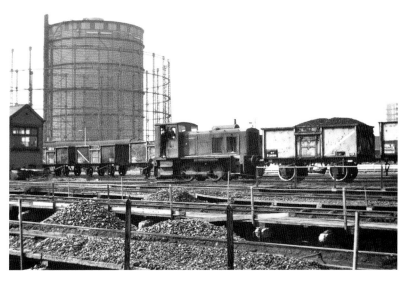

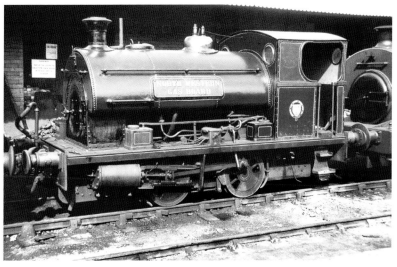

*Above right*: A Ruston & Hornsby 0-4-0 diesel-electric (W/No. 424839 of 1959) viewed from the coal drops at NWGB's Bradford Road Gasworks, Manchester, on 22 March 1969. The profile of this class is slightly larger than of the 165DE class, further altered by a unique exhaust arrangement. The Class 200DE Ruston survives today in the care of contractor Northumbria Rail Ltd at Bedlington. (John Sloane)

*Right*: Peckett 0-4-0 saddle tank *North Western Gas Board* (W/No. 1999 of 1941) was built for the Southport Corporation Gasworks, delivered resplendent in Midland Railway livery but bearing the Corporation's crest, for shunting Southport's Blowick exchange sidings. The NWGB transferred it to their Darwen works in 1958, but it was replaced by diesel traction in 1963. Acquired in 1966 for preservation, it spent some time on the Keighley & Worth Valley Railway, where it is seen at Haworth on 9 August 1970. It featured in the 1970 movie *The Virgin and the Gypsy*, working a train at Cromford in Derbyshire on BR metals. Unsuitable for Worth Valley traffic requirements, it was transferred to Southport's Steamport and can now be found at the Ribble Steam Railway museum at Preston. (Author)

*Above left*: A Motor Rail 'Tin Turtle' four-wheel petrol-mechanical (works details unknown) standing with a wagon in the tippler at NWGB Stretford Gasworks on 26 October 1958. (Peter Eckersley – author's collection)

*Above*: This design of four-wheel 'steeple-cab' shunter was a standard English Electric product of the 1920s and found use in several power stations up and down the country, some examples being used well into the 1970s. On 3 June 1967 the NWGB Clitheroe Gasworks still relied on the services of this overhead electric wire 1928-built example (W/No. 737 of 1928) to shunt the 16-ton coal wagons. Coal gas production ceased at Clitheroe during the following year. (Peter Eckersley – author's collection)

*Left*: A John Fowler 150 hp 0-4-0 diesel-mechanical (W/No. 22992 of 1942) at CEGB Howley power station, Warrington, on 29 May 1964. Supplied new to the Royal Ordnance Factory at Kirkby, it was acquired by the British Electricity Authority and previously worked at Clarence Dock and Connah's Quay power stations. (Peter Eckersley – author's collection)

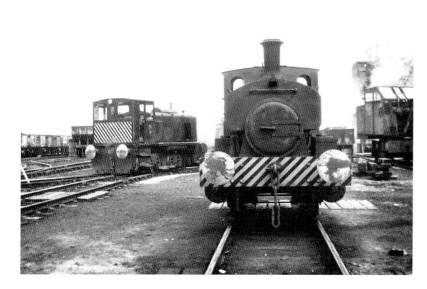

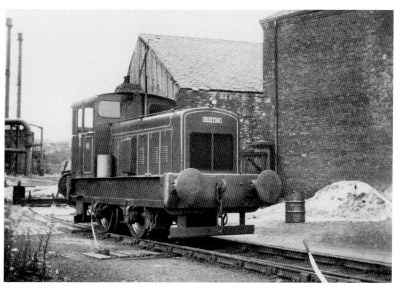

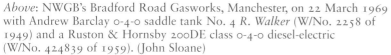

*Above*: NWGB's Bradford Road Gasworks, Manchester, on 22 March 1969 with Andrew Barclay 0-4-0 saddle tank No. 4 *R. Walker* (W/No. 2258 of 1949) and a Ruston & Hornsby 200DE class 0-4-0 diesel-electric (W/No. 424839 of 1959). (John Sloane)

*Above right*: Almost brand new 'out of the box', this Ruston & Hornsby 88DS class four-wheel diesel-mechanical (W/No. 435492 of 1960) is seen at NWGB's Bolton Gasworks on 22 July 1961. (Peter Eckersley – author's collection)

*Right*: An Andrew Barclay 0-4-0 saddle tank (W/No. 2197 of 1945) crossing a residential street on the branch serving NWGB's Rochdale Road Gasworks on 13 September 1952. (C. A. Appleton – IRS collection)

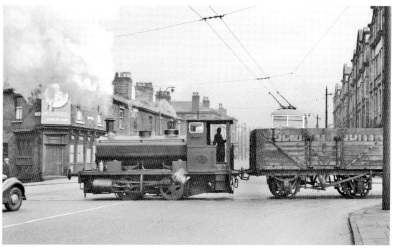

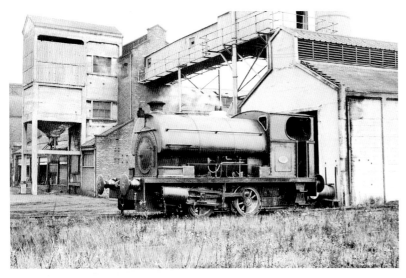

*Above left*: Peckett W7 class 0-4-0 saddle tank (W/No. 2130 of 1951) at Co-operative Wholesale Society Ltd (CWS), Irlam Soap & Candle Works in its last full year of service. In the early 1950s CWS called upon a fleet of six four-coupled Pecketts, reduced to four from 1952. This example was one of a pair delivered new to CWS and, upon closure of the internal railway, was purchased by Dunlop (along with sister W/No. 2131) for further use at Fort Dunlop works in Birmingham. Until September 1959 CWS operated a twice-daily workers' passenger service between their works and Irlam station, connecting with main line services. The Midland Railway six-wheel compartment coach used is now at the National Railway Museum (NRM). The Irlam works had several stationary boiler plants and ordered a fireless locomotive from Peckett, duly delivered in March 1955. The only such locomotive built by them, it proved to be considerably underpowered and saw very little use after 1960. The works was located alongside the Manchester Ship Canal, immediately to the west of the Irlam–Manchester railway, with Irlam Steelworks located on the opposite side of the railway. (Peter Eckersley – author's collection)

*Below left*: Hohenzollern 'Halle' class 0-4-0 fireless No. 1 (W/No. 4311 of 1925) at the British Enka Artificial Ltd's Rayon works at Aintree on 5 March 1966. Just six fireless locomotives originating from two overseas builders worked in Britain, including this lone example built by Hohenzollern A.G. at Düsseldorf in Germany. It was unique in Britain as the only fireless locomotive with inside cylinders, at the cab end between the frames. Supplied new to Wallasey Corporation Gas & Water Department, it was sold on to Wrexham dealer Cudworth & Johnsons Ltd, where it was rebuilt and resold to British Enka around 1945, working at the Aintree factory until scrapped around August 1968, although by the time of this photograph it appeared to have ended its working days, work being undertaken by a 1952-built Barclay fireless. The British Enka Artificial Silk Company was registered in 1925 by the Maekubee Company in Holland, holder of all foreign rights of the Enka Company, which had a factory established on the site of the former National Aircraft Factory at Aintree, where Bristol biplanes had been built during the war. British Enka was taken over by Courtaulds in 1961. (Peter Eckersley – author's collection)

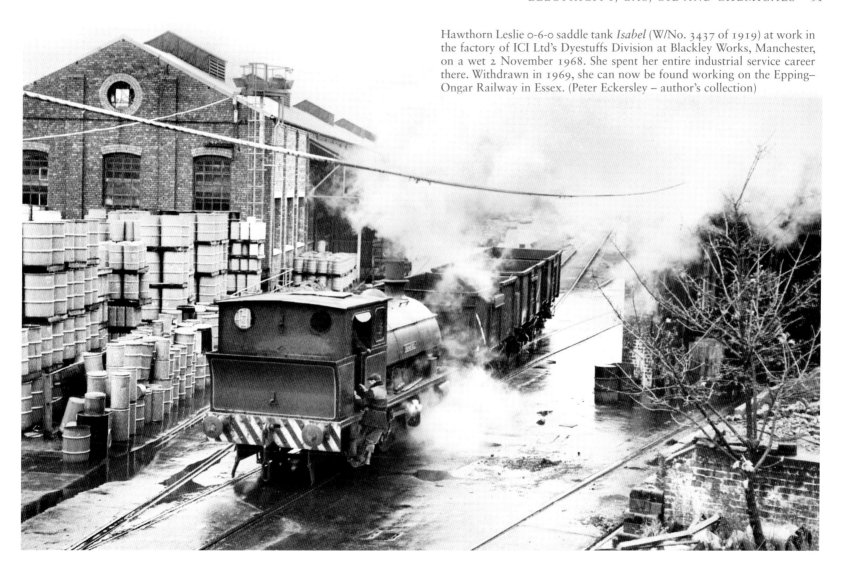

Hawthorn Leslie 0-6-0 saddle tank *Isabel* (W/No. 3437 of 1919) at work in the factory of ICI Ltd's Dyestuffs Division at Blackley Works, Manchester, on a wet 2 November 1968. She spent her entire industrial service career there. Withdrawn in 1969, she can now be found working on the Epping–Ongar Railway in Essex. (Peter Eckersley – author's collection)

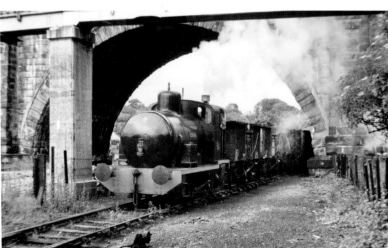

*Above left*: Huncoat power station's exchange sidings are being taken over by nature in this 1970 scene of William Bagnall 0-4-0 fireless *Huncoat No. 1* (W/No. 2989 of 1951) at work. The British Energy Authority ordered two such locomotives in January 1948 for Huncoat and Westwood power stations then under construction. Leading up to its closure in 1984, Huncoat had two Bagnall and one Hawthorn Leslie fireless, and a John Fowler diesel; all were despatched to Ward's of Ilkeston for scrap in 1986. (Author's collection)

*Left*: Lancaster power station's Andrew Barclay 0-6-0 fireless *Lancaster No. 1* (W/No. 1572 of 1917) passing beneath John Rennie's 1797-built Lune aqueduct with 16-ton mineral wagons on 28 June 1969. It was delivered to the Ministry of Munitions Queensferry factory, Flintshire, in January 1918, named *HM Factory Queensferry No. 10*, but later sold to Lever Brothers Ltd, Port Sunlight, and in 1924 sold on again, to Lancaster power station. Upon the power station's closure in 1981, this and a Barclay 0-4-0 fireless (*Lancaster No. 2*) were transferred to the nearby Heysham nuclear power station where they were available for occasional work, remarkably until around 1992. (John Sloane)

*Opposite page above right*: Robert Stephenson & Hawthorns Newcastle-built 0-4-0 saddle tank No. 2 (W/No. 7646 of 1950) at Hartshead power station, Stalybridge, on 12 April 1971. (John Sloane)

*Above right*: Two classic John Fowler 0-4-0 diesel-mechanical designs together at Howley power station, Warrington, on 7 March 1970. On the left is flame-proof 40 hp 812 (W/No. 22058 of 1937) along with a standard centre-cab 150 hp version (W/No. 22992 of 1942), both types of which were supplied to Royal Ordnance Factories (ROF), War Department and Admiralty installations between 1937 and 1945; in fact, the Leeds factory produced 195 locos during that period, mainly towards the war effort. Fowler's first internal combustion loco was built in 1923, supplied to Nelson Corporation's Brierfield Gasworks. The centre-cab 150 hp 28/30-ton design was produced in large numbers, mainly flameproof versions for ordnance depots. Both locos had such previous connections; No. 22058 was supplied new to ROF Irvine, and No. 22992 had been supplied new to ROF Kirkby. Howley was a coal-fired station situated on the bank of the River Mersey. Coal was carried by an enclosed conveyor belt system from the railway exchange sidings, which were located on the opposite side of the Mersey (John Sloane)

*Below right*: CEGB Carrington power station No. 2, a Hunslet 0-6-0 diesel hydraulic (W/No. 8977 of 1980), was maintained in good working order at the power station, where it was photographed outside the loco-shed on 2 September 1988, but it saw only intermittent work, handling the occasional train comprising oil, which was used for priming the boilers. The power station was built at the confluence of the Manchester Ship Canal and the River Mersey opposite Irlam Steelworks, at Trafford on the western outskirts of Manchester. After the UK's electricity supply industry was privatised in 1990, the coal-fired power station passed to PowerGen ownership and was closed soon after. It was not demolished until several years later. The locomotive was acquired by the Hunslet Engine Co. for positioning Class 323 EMUs then under construction at their Jack Lane works in Leeds between 1992 and 1993. It was later refurbished and sold on to Cumbria County Council's Workington Docks, where it continues to see occasional use. (Author)

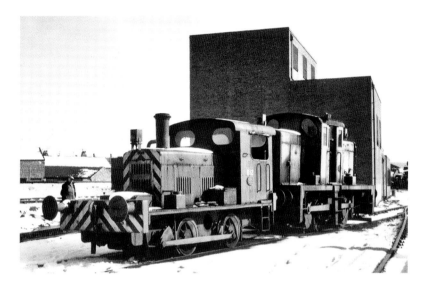

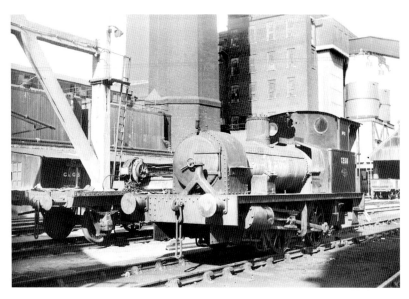

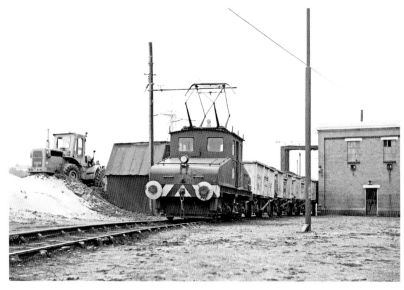

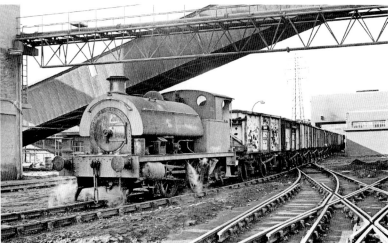

*Above left*: Newcastle-built Robert Stephenson & Hawthorns 0-4-0 saddle tank *CEGB No. 2* (W/No. 7541 of 1949) in a dismantled state at Stuart Street power station, Manchester, in November 1965. (Author's collection)

*Above*: Kearsley power station's Hawthorn Leslie 0-4-4-0 overhead electric loco No. 2 (W/No. 3872 of 1936) at the wagon discharge point in April 1975. The station, opened in 1929 and closed in 1981, had a fleet of four such locos to haul coal between the Manchester–Bolton railway exchange sidings and the power station, a section with a 1 in 22 gradient. (Author's collection)

*Left*: Robert Stephenson & Hawthorns Newcastle-built 0-4-0 saddle tank *Agecroft No. 3* (W/No. 7681 of 1951) shunting wagons at the discharge point at Agecroft power station in the early 1970s. (Author's collection)

*Opposite page*: Hawthorn Leslie 0-6-0 fireless *Hartshead* (W/No. 3805 of 1932) is at work in the exchange sidings at Hartshead power station, Stalybridge, on a misty 15 April 1967. (Peter Eckersley – author's collection)

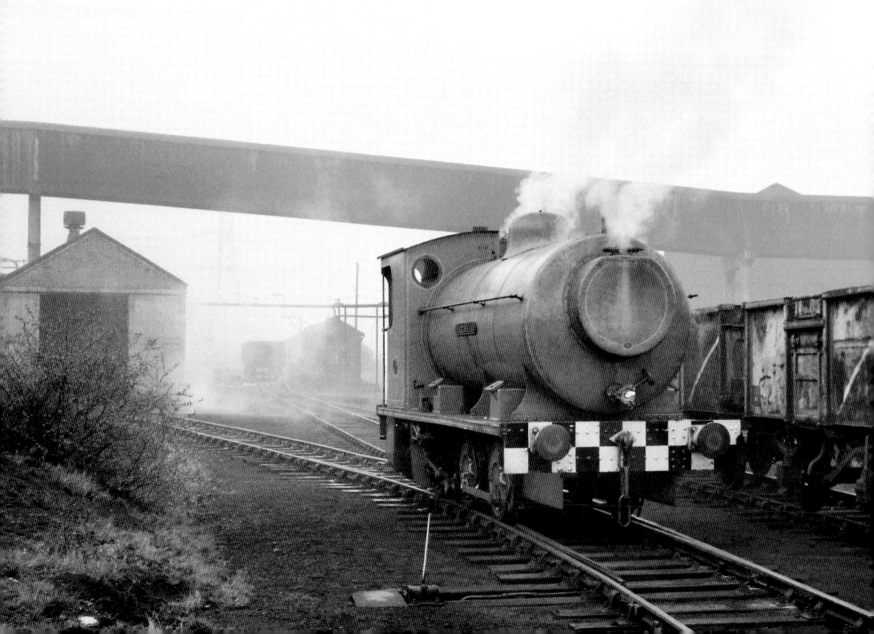

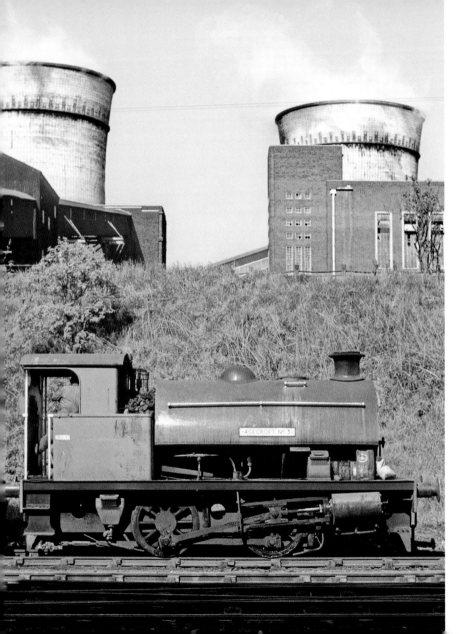

*Left*: Agecroft power station (or, to be more correct, power stations, as there were three – A, B and C) stood on a restricted site between the eastern bank of the Manchester, Bury & Bolton Canal and the western bank of the River Irwell. Because of the geographical limitations of the site, the power station's sidings were built on the western side of the Manchester to Bolton railway line, which ran along the western bank of the canal at this point. Coal delivered to these sidings was transferred to the power station by an enclosed overhead conveyor belt, taking it over both the railway and canal. Coal was also delivered directly from the nearby Agecroft colliery at Pendlebury, again by an enclosed conveyor; this coal was also fed into the conveyor over the railway and canal. When coal from Agecroft colliery was sufficient for the station's needs there was no work for the railway, but at other times it was very busy. Rail traffic ceased in September 1981, after which Agecroft colliery continued to satisfy the power station's requirements until it ceased winding in 1990 and coal was delivered thereafter by road from other mines. The power station did not close until 1993 and there is now a prison on the site, while the railway sidings have been lifted and the area is now a public open space. The railway had a stud of three Robert Stephenson & Hawthorns 0-4-0 saddle tanks and, on 2 May 1980, the eastern road of the tippler was in use. *Agecroft No. 3* poses against a power station backdrop as it waits for another of its wagons to be emptied in the tippler. BR's Manchester to Bolton line is on top of the embankment behind the loco. (Richard Stevens)

*Opposite page*: An earlier scene of a begrimed *Agecroft No. 3* in a plain black and red livery, heading a rake of loaded BR 16-ton coal wagons through the tippler on 7 May 1966. Once the last wagon was clear of the tippler, the loco would slowly reverse its train, allowing each wagon in turn to be unloaded, after which the empties would be returned to the sidings. The overhead enclosed conveyor belt fed the power station from Agecroft colliery. (Author's collection)

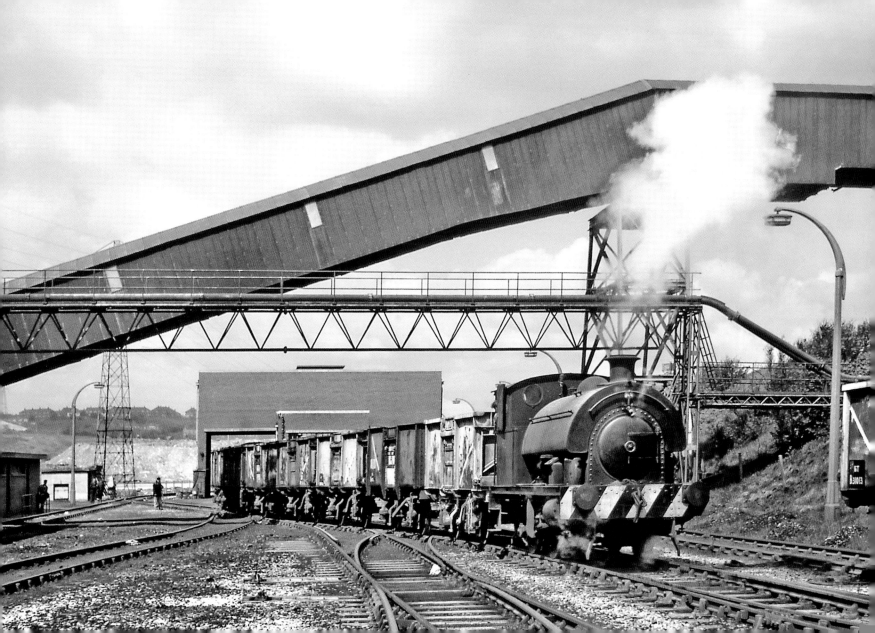

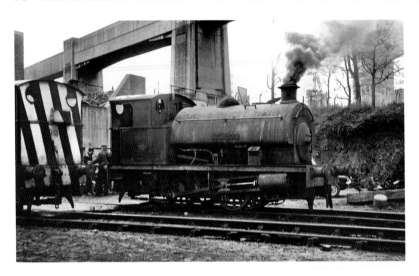

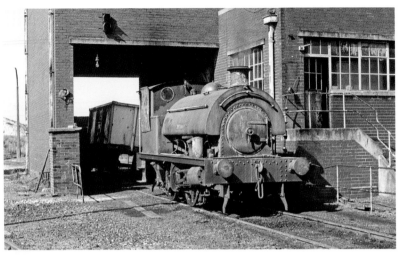

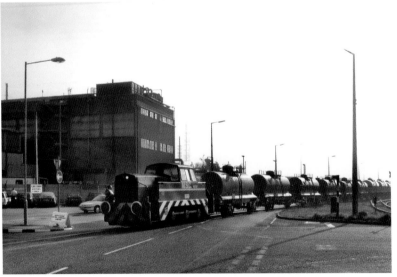

*Above left*: A filthy *Agecroft No. 3* raising steam outside the Agecroft power station's loco-shed in the late 1960s. (Author's collection)

*Above*: On 18 September 1977 *Agecroft No. 2* (W/No. 7485 of 1948), running without nameplates, waits outside the westernmost line of the wagon tippler as the contents of its last wagon are emptied down the chute onto the underground conveyor. This ritual was to continue until 12 September 1981, when the last steam shunting took place at Agecroft. (Richard Stevens)

*Left*: At 9.00 a.m. on a misty 15 April 1993, MSSC 'Sentinel' 3003 (W/No. 10146 of 1963) delivers empty ammonia tanks to Associated Octel Ltd at Ellesmere Port. (Author)

*Opposite page*: On the cold and frosty morning of 12 October 1990 there is a surprising amount of activity at Shell's Stanlow sidings. Thomas Hill *Vanguard No. 9* (W/No. 287V of 1980), with its 'scrubber' quenching system exhausting steam, is busy shunting, while *Vanguard No. 3* (W/No. 235V of 1971) stands on tanker wagons on an adjacent siding. Beyond, BR No. 47102 has just arrived at the head of empty tanker wagons and No. 47003 *Wild Swan* passes on the main line with intermodal containers for Ellesmere Port. (Author)

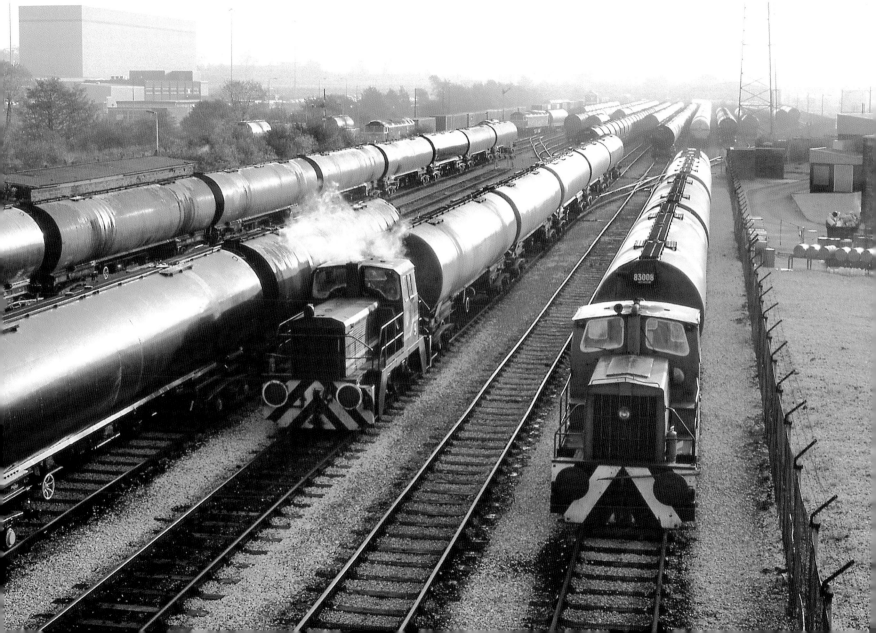

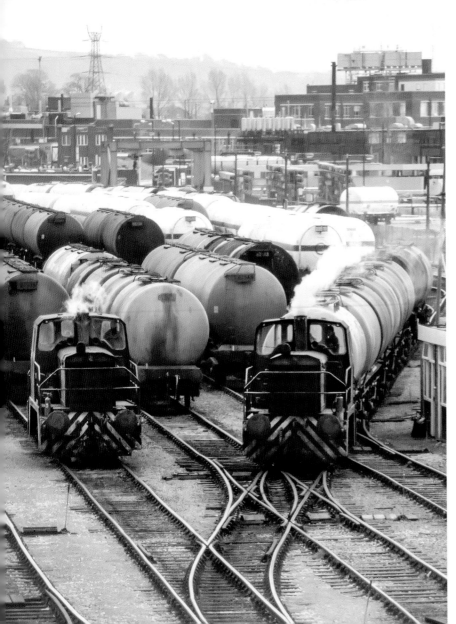

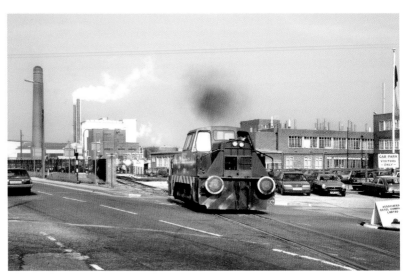

*Above*: MSSC 'Sentinel' No. 3003 returns to the Ellesmere Port sidings, having deposited wagons at the works of Associated Octel Ltd on 15 April 1993. (Author)

*Left*: When Shell UK Oil Ltd was still a major user of rail freight in the UK the vast Stanlow Refinery, established in the 1920s, was one of the busiest, with trains of various products dispatched to numerous destinations over a 24-hour period. Shell's loco fleet during this visit on 16 March 1989 comprised seven locos, all except one being of the Thomas Hill 'Vanguard' type. In such an explosive and fire hazardous location, locos were fitted with exhaust 'scrubbers' to dampen exhaust emissions. Here No. 9 (W/No. 287V/1980) stands on the left while sister loco No. 8 (W/No. 288V/1980) draws a train of empty tanker wagons from Thornton South Reception Yard towards the loading racks with steam wafting from the exhaust. This fourteen-road yard filtered into a five-road filling shed, where the tankers were loaded before being drawn out into a thirteen-road departure yard where a BR locomotive would collect the loaded trains. (Adrian Nicholls)

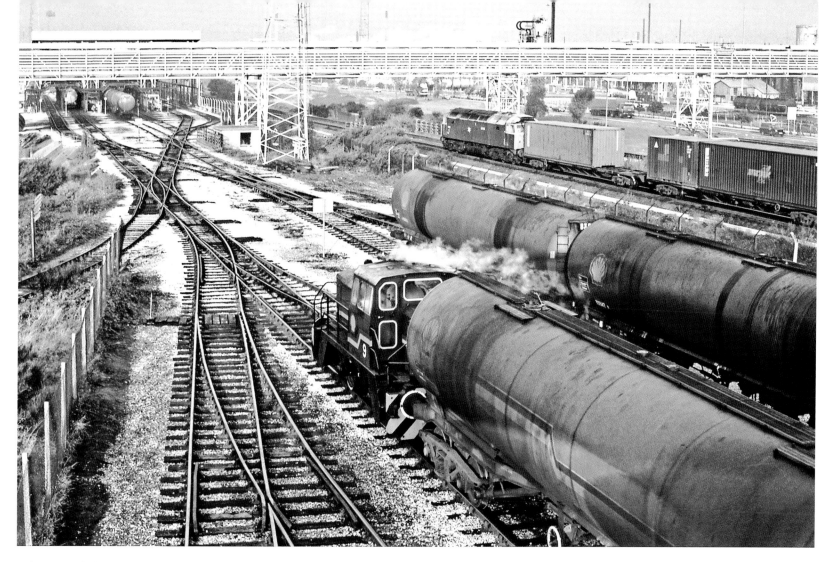

A busy interlude as the early morning autumnal sunshine on 12 October 1990 illuminates 'Vanguard' No. 9 shunting the exchange sidings at the Stanlow Refinery. Tinsley-based No. 47003 *Wild Swan* is passing with a container train for Ellesmere Port. (Author)

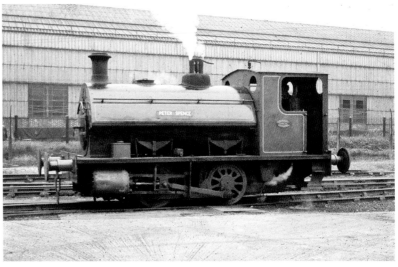

*Above left*: A Rolls-Royce 'Sentinel' four-wheel diesel-hydraulic (W/No. 10194 of 1964) at the British Salt Company's Middlewich Salt works' loading sidings on 5 April 1993. The loco has found further use in preservation at the Ecclesbourne Valley Railway in Derbyshire. (Adrian Nicholls)

*Above*: Kerr Stewart 0-4-0 saddle tank *Peter Spence* (W/No. 4150 of 1950) at Peter Spence & Sons Ltd, Chemical Manufacturers, Farnworth, near Widnes, in the early 1960s. It was purchased, after repair by the Hunslet Engine Company, in December 1949, and had previously worked for the MD&HB as their fleet No. 31. (John Sloane)

*Left*: Brunner Mond, Lostock Works, Northwich, produced soda ash from the Cheshire salt deposits. On 24 January 1994 Ruston & Hornsby 0-4-0 diesel-electric *Rutherford* (W/No. 412710 of 1957) stands with a train of limestone conveyed in the iconic LMS 71-ton 'PHV' hoppers, for many years associated with workings between the Buxton quarries and the Cheshire ICI plants. At this time, Lostock Works had three four-coupled shunters for on-site rail movements, all being of the Ruston 165DE class, as seen here. (Adrian Nicholls)

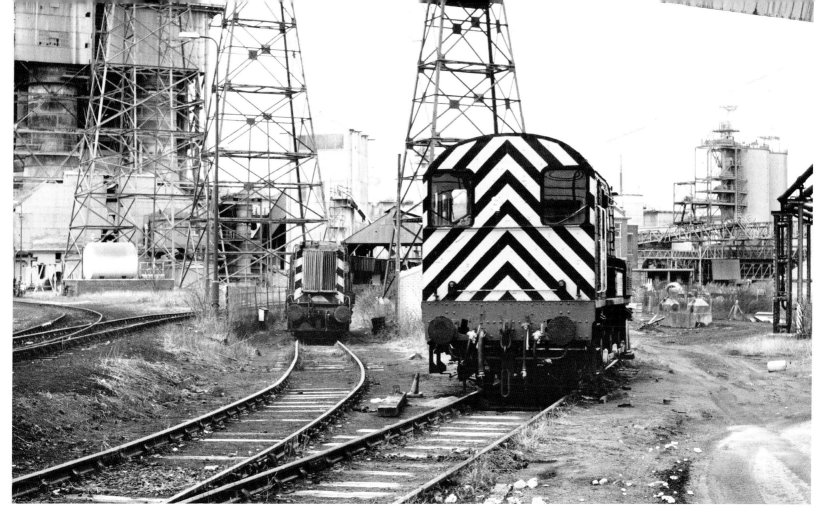

Brunner Mond, Winnington Works, on 24 January 1994 with (in the foreground) ex-BR Class 08 No. 08867 owned by RMS Locotec Ltd carrying their hire loco number HL1007. It had arrived on site just a couple of weeks earlier to replace one of the company's own 0-6-0 diesel-electrics, which had suffered a mechanical failure. Standing behind is English Electric *Perkin* (W/No. 1904 of 1951), an industrial version of the successful 350 hp shunter deployed by BR in the shape of a Class 08/09, hence the familiar outline. ICI had four of these delivered new to the works in 1951 and all carried names. By this date only two remained at Winnington, two having been sold for scrap in March 1987. (Adrian Nicholls)

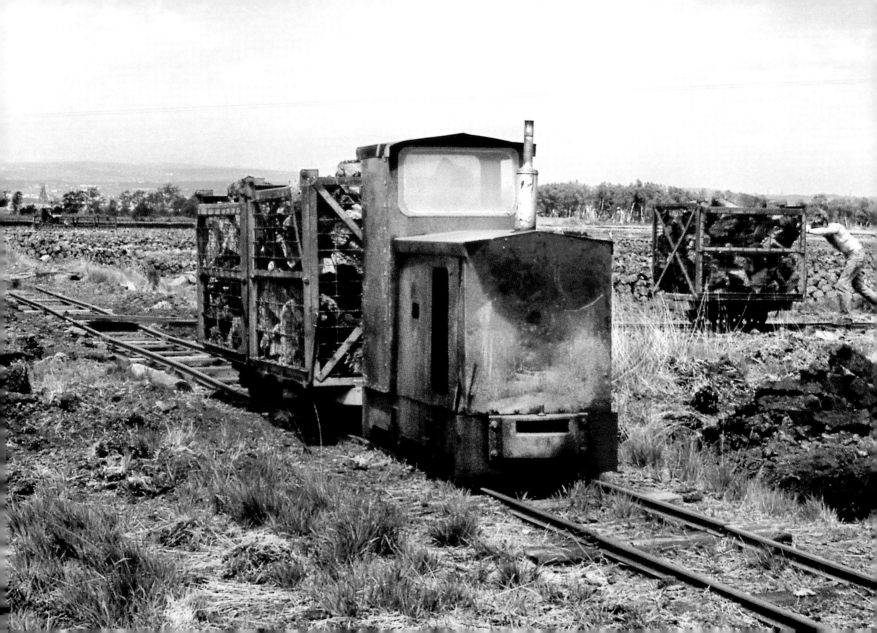

# ON THE NARROW GAUGE

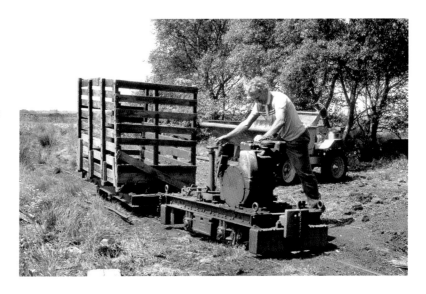

*Opposite page*: The Chat Moss peat bog 2-foot gauge tramway of Croxden Horticultural Products, near Irlam, on 26 May 1989, with an Alan Keef four-wheel diesel-mechanical (W/No. 5 of 1979) standing out on the moss on the 'main running line'. Loaded cars of hand-cut peat are being hand-propelled along a temporary line to make up a complete train for conveyance along the 'main line' to the discharge point at Twelve Yards Road, where the peat wagons would be drawn by a winch over the tippler. This tipping method was subsequently replaced by a JCB lifting a later version of wagon off the track and tipping the contents onto a stockpile for onward road transportation from site. Astley Green colliery is just discernible on the horizon to the left. (Author)

*Above right*: One of the smaller peat operations to be found on Chat Moss near Irlam was that of Adams Peat Products. This was a hand-dug peat operation using mostly hand-worked wagons on the short 2-foot gauge system, utilising just a couple of peat cars. This 1936 vintage Lister four-wheel diesel-mechanical (W/No. 7954) saw only occasional use, as was the case on this 26 May 1989 visit. Established by at least the early 1960s, the Four Lane Ends Mill was closed around 1999/2000. This was the first official Lister conversion from petrol to diesel and it is now privately preserved at the Canalside in Ripon, North Yorkshire. (Author)

*Below right*: The Chat Moss peat bog 2-foot gauge tramway of Croxden Horticultural Products with an Alan Keef four-wheel diesel-mechanical (W/No. 5 of 1979) propelling five empty peat cars out on the moss as loaded peat cars are waiting to be taken to the discharge point at Twelve Yards Road, Irlam. The mill was originally opened in the early to mid-1960s and became an extensive network of lines by the time of this photograph on 26 May 1989. Peat extraction ceased in late 1997, although the railway was used through the following year to remove stockpiles out on the moss. (Author)

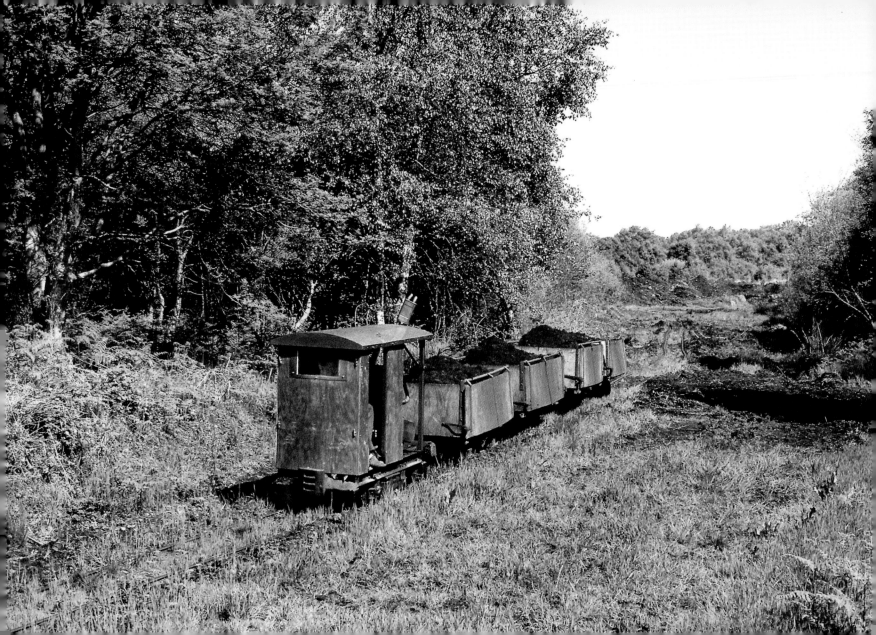

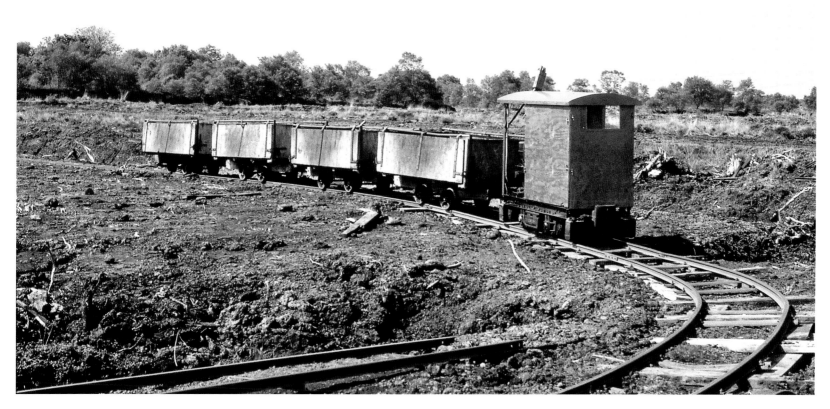

*Opposite page & above*: Middlebrook Mushrooms Ltd, Wilmslow. A 2-foot gauge Lister Blackstone four-wheel diesel-hydraulic (W/No. 50888 of 1959) is moving loaded peat cars to the Moor Lane mill from Lindow Moss near Wilmslow on 26 May 1989. The 'Railtruck' had previously been used by the Eclipse Peat Company in Somerset and the wagons at Wilmslow were based on the type used at the Ashcott works in Somerset, but using plywood sheets instead of wooden slats for the side and end panels. The operation demanded two sets of four wagons, being propelled to the moss empty and hauled back to the mill, with one loco in use. 'Slip working' was employed and the full wagons pushed by hand over the tippler feeding a conveyor below. (Both author)

*Right*: Close to the Summit Level near Littleborough on 24 June 1992, one of two Alan Keef Ltd contract hire 2-foot gauge four-wheel diesel-mechanical Motor Rail 'Simplex' locomotives, this example being W/No. 21513 of 1955, is at the head of a works train being loaded with silt while on hire to Dew Construction Ltd for the restoration of the Rochdale Canal near Littleborough. Officially opened in 1804, the canal runs across the Pennines for 32 miles between the Bridgewater Canal at Castlefield Basin in Manchester and the Calder & Hebble Navigation at Sowerby Bridge. Its locks were built wide enough to allow vessels of 14 feet in width. Most of the canal was closed in 1952, apart from a short section in Manchester serving the Bridgewater and Ashton canals, which continued to be used by commercial traffic. The last complete navigation of the Rochdale Canal had allegedly taken place in 1937 and by the 1960s most had been taken over by nature and was not navigable. (Author)

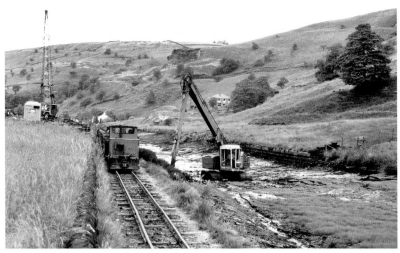

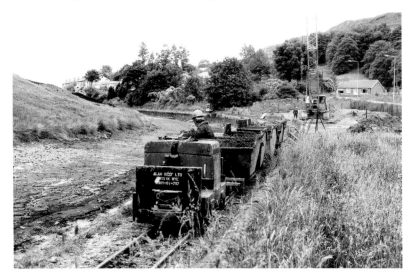

*Left & opposite page*: A Motor Rail 'Simplex' (W/No. 21282 of 1957), on hire to Dew Construction Ltd from Alan Keef Ltd at Ross-on-Wye, working on the Rochdale Canal restoration contract, running along the temporarily laid 2-foot gauge tramway installed on the towpath at Summit Level, near Littleborough, on 24 June 1992 due to restricted motor vehicle access. The canal was restored and reopened in sections; nine locks between the junction with the Ashton Canal and the Bridgewater Canal in 1974 and the section from Todmorden to Hebden Bridge in May 1983. The entire section from Sowerby Bridge to the summit at Longlees reopened in 1990, remaining isolated from the rest of the canal network. Further funding enabled this restoration work, using the narrow-gauge tramway, to be undertaken by the contractors and the first boat to pass over this route and the Calder & Hebble Navigation did so in April 1996. The diminutive 20/28 hp 'Simplex', originally supplied to the London Brick Company's Kempston Hardwick brickworks in Bedfordshire, can now be found on the Lea Bailey Light Railway near Ross-on-Wye. (Author)

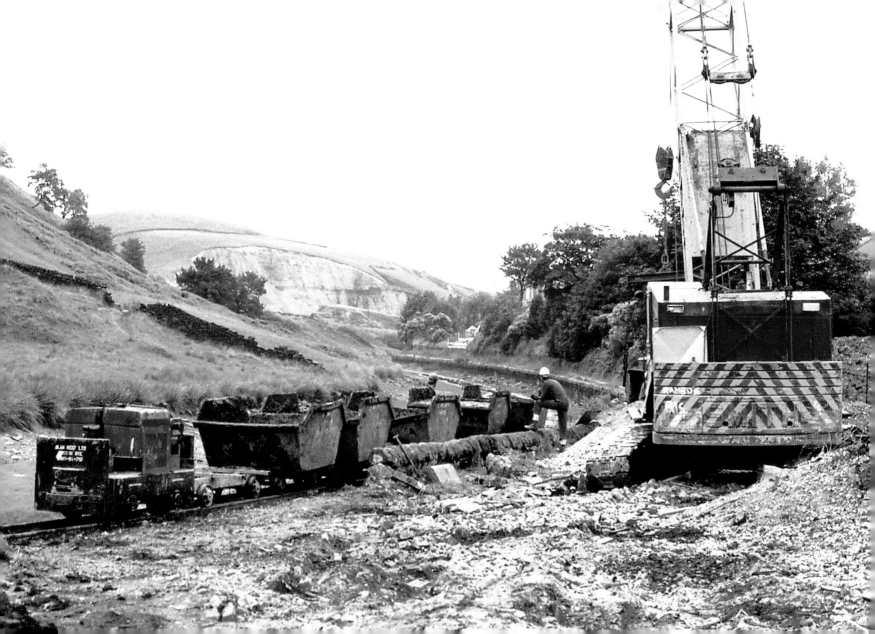

*Above left & right*: The J. Whittaker & Son stone quarries on Scout Moor, Ramsbottom, on 2 February 1957 with the remains (*above left*) of 3-foot gauge Aveling & Porter 2-2-0 geared tank *Excelsior* (W/No. 1607 of 1880), originally taken out of service in 1910! A William Bagnall 0-4-0 saddle tank (W/No. 1736 of 1904) was the working locomotive until 1939, when an earth slip took the tramway some thirty feet down the hillside, and it was never replaced. On 29 July 1962 (*above right*), it was still in its shed, which had suffered an arson attack. Originally opened in 1880, the quarry workings are still active today. (Both Peter Eckersley – author's collection)

*Left*: Ruston & Hornsby 1-foot 6-in. gauge Class LAT 20 hp four-wheel diesel-mechanical ZM32 (W/No. 416214 of 1957) at BR Horwich Works in September 1963, six months before its withdrawal. Replacing the Beyer Peacock saddle tank *Wren*, now on display at the NRM, it was employed for eight years moving works materials. An export deal to British Honduras fell through, and it remained in store at Horwich until 1971, eventually being purchased for private use in Wales, re-gauged to 2 feet. (Author's collection)

*Right*: Ruston & Hornsby 2-foot gauge 20DL class four-wheel diesel-mechanical No. 33 (W/No. 218016 of 1943) on the moss at the Nook Lane works of Lancashire Moss Litter Company Ltd at Astley on 1 March 1969. The works was closed, and the railway dismantled in 1975, but the operation was subsequently reopened for surface-milled peat using tractors and trailers instead of the original method of cutting peat blocks, as seen here. Remains of the Ruston survive in a dismantled condition on the heritage Leighton Buzzard Railway in Bedfordshire. (Peter Eckersley – author's collection)

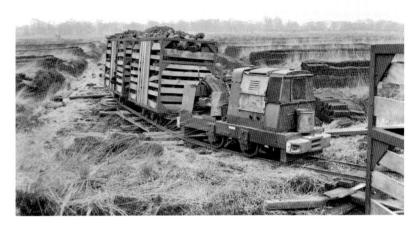

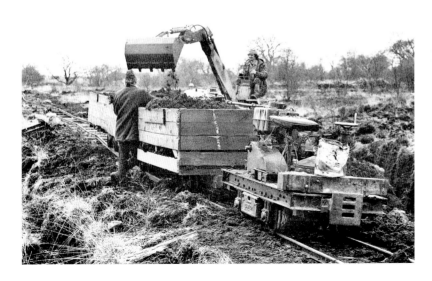

*Left*: Country Kitchen Foods Ltd's 2-foot gauge Lister Blackstone RM class four-wheel diesel-mechanical (W/No. 52528 of 1961) with wagons being loaded on the peat moss serving the Moor Lane (the former Fina Peat Company) works at Wilmslow on 4 April 1975. The company was bought out by Middlebrook Mushrooms Ltd around 1989 (*see page 107*). Following two further company takeovers, rail traffic ceased during 2000 and the locomotives and equipment were placed into storage on site pending possible use elsewhere, and were still believed to be there some fifteen years later. (David Haynes – IRS collection)

*Right*: The 2-foot 2-in. gauge surface system at Sutton Manor colliery on 6 March 1969 with LB class Ruston & Hornsby four-wheel diesel mechanical DL18 (W/No. 392107 of 1955). Delivered new to the colliery, it was scrapped in the late 1980s. Dating back to 1906, Sutton Manor was one of the last in Lancashire to close, in May 1991. At its height of production in the 1960s, 1,500 workers were employed, producing around 600,000 tonnes of coal per annum. In fact, when it was closed on the grounds of non-economic viability and profitability, the 450 remaining miners had been producing an output of over 450,000 tonnes per annum, and only eight months before closure had broken the colliery's long-standing production record of 12,000 tonnes in a single week. The devastation and disbelief among the workers and community can easily be appreciated with such statistics, during an era of widespread pit closures throughout the country. (John Sloane)

*Left*: Bank Hall colliery at Burnley used a 3-foot 6-in. gauge railway for the stockyard and on 8 April 1969 Ruston & Hornsby Class 20DL four-wheel diesel-mechanical *Dennis* (W/No. 354034) was the sole remaining locomotive of an identical pair delivered new to the colliery in 1953. It was, by the time of this visit, out of use and is believed to have been scrapped two months later; however, the standard gauge connection at the colliery still witnessed steam traction at this time (*see page 76*). (John Sloane)

*Above right*: On 6 September 1988 Robert Hudson 2-foot gauge four-wheel diesel-hydraulic *Chaumont* (W/No. LX1002 of 1968) is seen at the North West Water Authority's (NWWA) Ashton works, Dukinfield, Cheshire. Originally opened in 1903, by 1988 there was little work at the works for the weed-infested railway and its unusual loco, which linked the southern end of the water treatment plant with the facility's northern limits. Hudson built just two of these diesel-hydraulic locomotives, which were advanced for their time, and essentially demonstrator locomotives for a market that unfortunately turned out to be rapidly diminishing. *Chaumont* was placed on loan to the CEGB for evaluation on their 3-mile line through the former BR Woodhead tunnel, working alongside their 1961-built 48DL class Ruston & Hornsby locomotive on workers' trains in conjunction with ongoing cable installation works. CEGB decided instead to order a Clayton battery-electric loco and *Chaumont* was returned to the Leeds factory. It was eventually sold on by Hudson to the Ashton-under-Lyne Corporation (later NWWA) in July 1971 to replace an elderly Kent Construction petrol-mechanical and 1951-built Frank Hibberd Planet diesel-mechanical loco. The railway system was abandoned in 1993 and *Chaumont*, named after Ashton-under-Lyne's twin town in France, was acquired for preservation by the Moseley Railway Trust and is today based on the heritage Apedale Railway in Staffordshire. (Author)

*Below right*: Pilkington Brothers Ltd operated several nominal 2-foot gauge tramways (they were in fact gauged at an eighth of an inch over 2 feet!) at temporary locations in the Bickerstaffe, Knowsley, Rainford, Ormskirk and Skelmersdale areas. The company had commenced sand extraction at Rainford in 1880 and Mill Lane sand wash was the narrow-gauge complex, where sand was transhipped into the company's own private user standard-gauge hopper wagons for transfer to the St Helens sheet glass works; this dual-gauge transhipment operation ceased in January 1967 upon the closure of the St Helens to Rainford Junction line. By the end of the 1960s the fleet comprised thirteen Motor Rail 'Simplex' four-wheel diesel-mechanical locos built between 1959 and 1968; the narrow-gauge operation ceased totally at the end of March 1978. On 29 November 1975 *Topsy* (W/No. 11141 of 1960) is at the Stanley Gate workings at Scarth Hill with sand for the Mill Lane sand wash. (John Sloane)

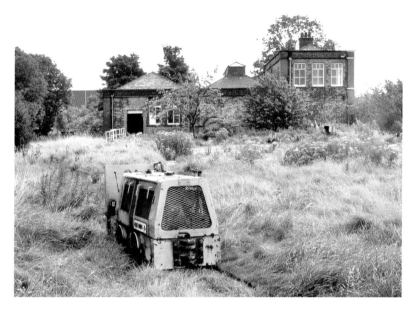

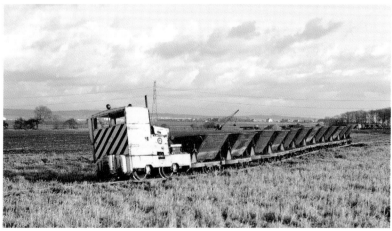

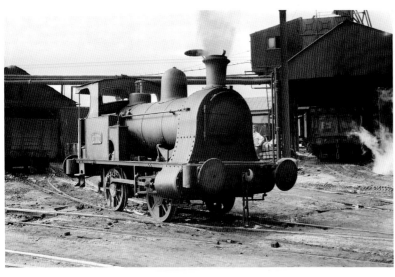

# SAND AND GLASS

*Above & below left*: Glass manufacture in St Helens commenced around 1826 and, with the coming of the railway, the Pilkington Brothers Ltd works rapidly expanded until, at its peak of manufacture in the 1950s, Pilkingtons, with its dominant market share in glass manufacture, was handling in the region of 1,800 railway wagons per week at St Helens. The company also owned St Helens colliery until vesting day, providing cheap coal right on the doorstep for the manufacturing processes. Products handled at the Ravenhead, Gerards Bridge and Crown Sheet works were inbound coal and sand (and later oil, replacing coal in the late twentieth century) and outbound finished product in bespoke wagons for safely conveying large sheets of manufactured glass. Pilkingtons was a loyal user of the locally built Edward Borrows 'Cross'-design 0-4-0 well tanks from the local Providence Works and drew, at various times, from a fleet of nineteen such locos built between 1875 and 1910, although locos from other manufacturers were also used. Similar Borrows locos also worked at the Brunner Mond Winnington and Lostock works at Northwich in Cheshire and at the United Alkali Burn Naze works at Fleetwood in Lancs. Borrows 0-4-0 well tank *Sutton* (W/No. 49 of 1905) was photographed (*above left*) at St Helens Sheet Works (formerly Crown plate glass works) in the mid-1950s. It was withdrawn from service in April 1959 and scrapped during 1960. At the Cowley Hill Plate Works in the mid-1950s *(below left)* Borrows 0-4-0 well tank *Briars Hey* was at work. It was a 1954 rebuild, using the frames of *Roby* (W/No. 33 of 1892) and the reconditioned boiler of *Briars Hey* (W/No. 52 of 1908). Such Pilkington rebuilds were commonplace, the locos adopting the boiler identity and not the donor frame, unlike normal practice elsewhere. Therefore, true identities of four locos usually found in service at any given time were open to conjecture! This hybrid was scrapped in 1960. Another Borrows tank (*opposite page*) emerges from the fire well, again in the mid-1950s. Pilkington's regular steam working ceased around 1960 with an influx of new diesels, although No. 5 (*see page 116*) was retained at Ravenhead works until the late 1960s, being oil-fired.

The Pilkingtons internal railway systems were finally closed at the end of March 1984, the work of the remaining fleet of five Yorkshire Engine diesels at Cowley Hill being replaced by road transport. (All author's collection)

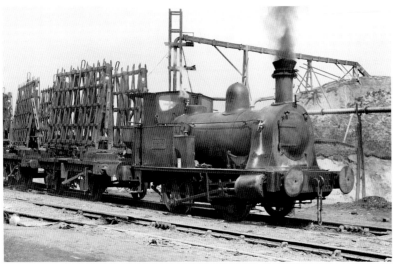

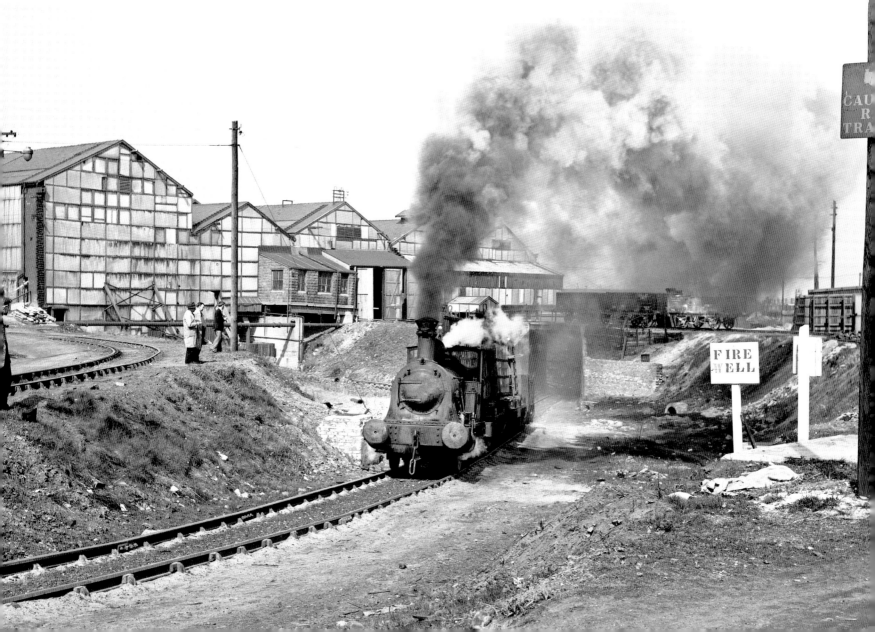

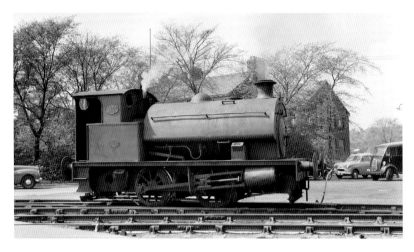

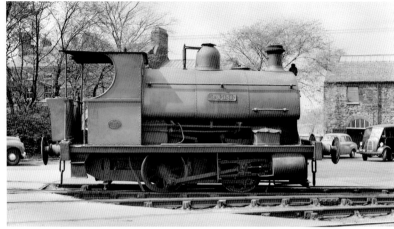

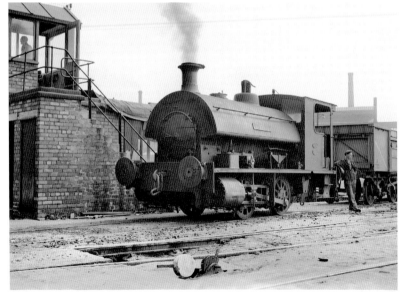

*Above left*: Working during this 1950s visit to the Ravenhead Works was Robert Stephenson & Hawthorns 0-4-0 saddle tank R.O.F. 9 No. 5 (W/No. 7046 of 1941), acquired from Aycliffe Royal Ordnance Factory in 1946. It was converted to oil-burning in 1962, but was scrapped in April 1969. (Author's collection)

*Above*: Peckett 0-4-0 saddle tank *Daphne* (W/No. 737 of 1899) at Ravenhead works in the mid-1950s. Acquired by Pilkingtons from the Tytherington Stone Co. in 1923, she is now a static exhibit at the Ribble Steam Railway. (Author's collection)

*Left*: The Crown Sheet Works on 6 May 1956 found Kerr Stewart 0-4-0 saddle tank *Victory* (W/No. 4148 of 1920) working. This 'Moss Bay' class had been purchased new 'off the shelf' from the Stoke-on-Trent factory. Its bestowed name was a popular choice during this post-war period. It was scrapped on site around 1962. (Kevin Lane collection)

*Opposite page*: Borrows 0-4-0 well tank *Briars Hey* and crew pausing between shunting duties at the Cowley Hill Plate Works in the mid-1950s. The hopper-style bunker of this rebuilt hybrid loco is prominent in this view. (Author's collection)

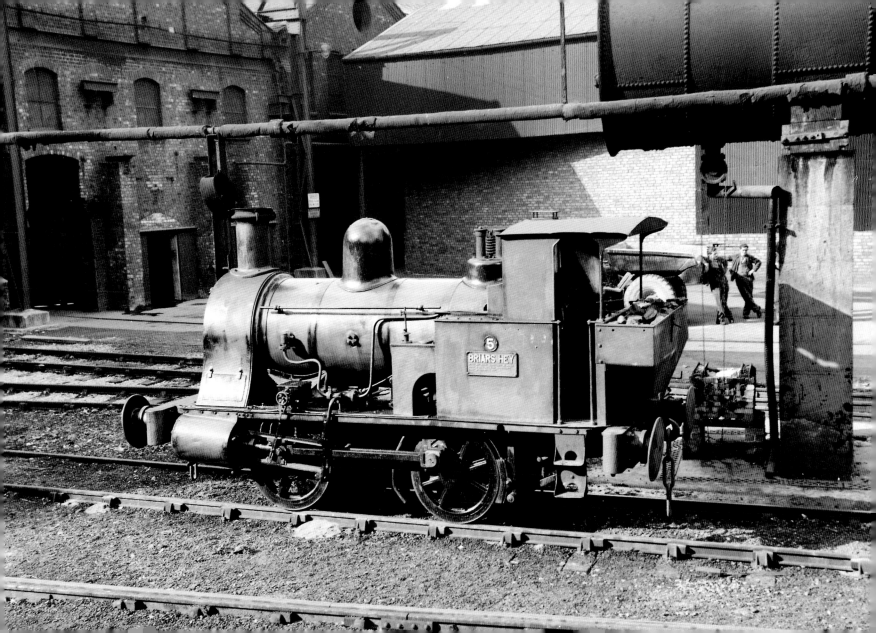

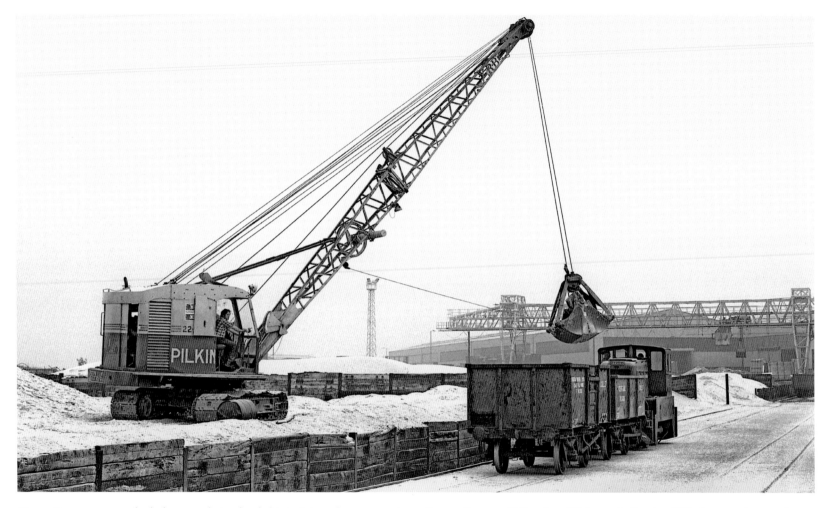

On 11 June 1979, crushed glass was being loaded into internal wagons using a Ruston Bucyrus 'RB-22' at Pilkington's Cowley Hill glass works on what at first glance appears to be a winter snow scene, but is in fact sand and crushed glass. In attendance was Yorkshire Engine 0-4-0 diesel-electric *Cowley Hill* (W/No. 2687 of 1958), one of five such locos on the company's books at the time. (Kevin Lane)

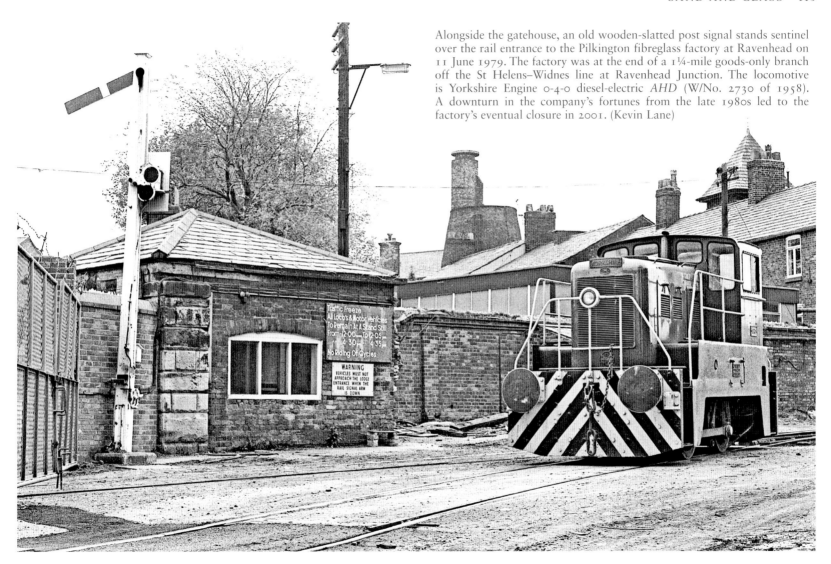

Alongside the gatehouse, an old wooden-slatted post signal stands sentinel over the rail entrance to the Pilkington fibreglass factory at Ravenhead on 11 June 1979. The factory was at the end of a 1¼-mile goods-only branch off the St Helens–Widnes line at Ravenhead Junction. The locomotive is Yorkshire Engine 0-4-0 diesel-electric *AHD* (W/No. 2730 of 1958). A downturn in the company's fortunes from the late 1980s led to the factory's eventual closure in 2001. (Kevin Lane)

*Right*: Yorkshire Engine 0-4-0 diesel-electric No. 1 *Peasley* (W/No. 2653 of 1957) at the United Glass Ltd Peasley bottle works, St Helens, on 4 September 1988. From as early as the 1870s, St Helens became known as the country's premier bottle making centre. The technique of using tank furnaces enabled fast mass production and the consequent expansion of world export business opportunities. (Author)

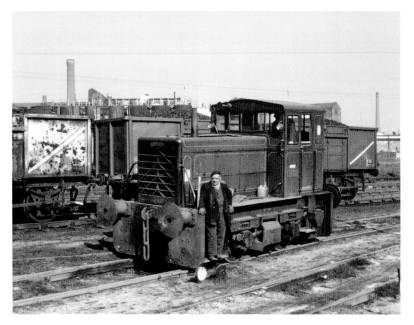

*Left*: At the United Glass Ltd Peasley Works on 6 March 1969 was Frank Hibberd four-wheel diesel-mechanical *Sherdley* (W/No. 4007 of 1963), one of three such 'Planet' locos on the company's books. Locos were used at three of the company's works at St Helens, located at Peasley, Ravenhead and Sherdley. (John Sloane)

*Opposite page*: The Yates Duxbury Heap Bridge paper mills' anonymous Andrew Barclay 0-4-0 saddle tank (W/No. 945 of 1904) propels sheeted china clay wagons along BR's Heap Bridge branch towards the sidings for the north (No. 2) mill. Yates Duxbury locos had running rights over the branch to enable them to transfer wagons between the company's mills, which lay on opposite sides of the main Bury to Heywood road, with the BR line providing the only rail connection between the two. The 'Pug' is passing Heywood Goods Yard in bitterly cold conditions during 1972. This yard had closed to general freight traffic in 1967, and the sidings were then being used exclusively for mill traffic, with branches to their south (No. 1) mill leading off from these sidings. (Author's collection)

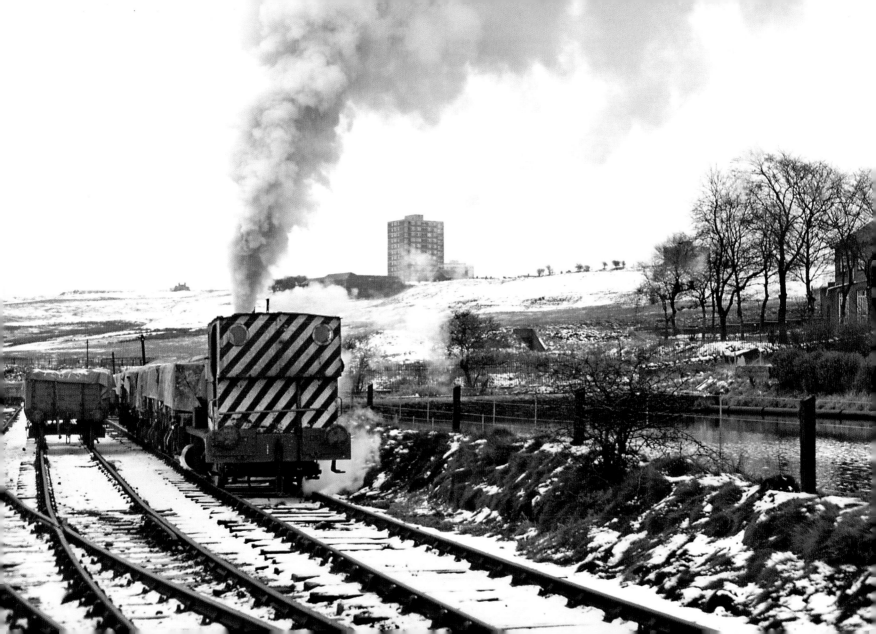

# 13

# PAPER

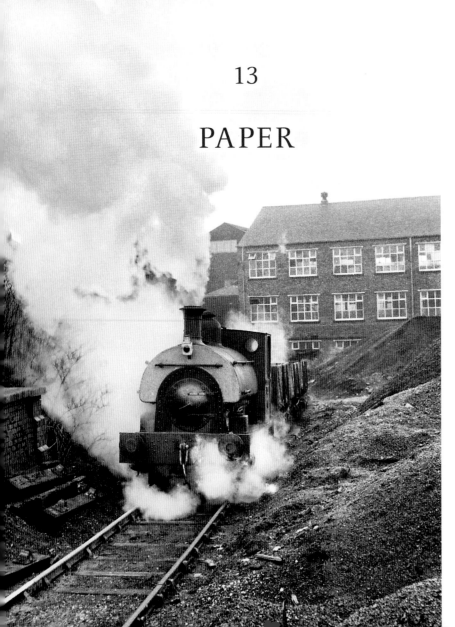

*Left*: The Heap Bridge paper mills were located near Heywood, Lancashire, where paper making can be traced back to 1810. Yates Duxbury had been established at Heap Bridge since taking over the insolvent Heap Bridge Paper Company in 1882. A second mill was opened in 1908. By the 1960s the rail traffic handled included baled wood pulp from Preston Docks, coal and china clay. Containerised pulp from Manchester Docks was also occasionally delivered. Steam traction was used to move bulk traffic that had been delivered by BR to the exchange sidings on the freight-only Heap Bridge branch off the Bury to Heywood line (now part of the heritage East Lancashire Railway), and to shunt other traffic around the mills in internal user wagons. The internal railway system was used seven days per week right up until closure, and notably it was one of the very last non-NCB industrial railways in the North West to employ conventional steam traction. The mills were finally closed in 1981. On 11 May 1965 (*left*) Peckett 0-4-0 saddle tank *May* (W/No. 1370 of 1915), in poor condition and leaking steam profusely, pulls internal user wagons away from the north (No. 2) mill past the huge stockpile of coal which fed that mill. The R2 class Peckett had been acquired pre-owned from English Electric at Stafford in 1932. (Author's collection)

Some seven years later, on 5 August 1972 (*opposite page*), the company's anonymous Andrew Barclay 0-4-0 saddle tank (W/No. 945 of 1904), again purchased second-hand in 1944 from George Cohen in Leeds, runs through the weed-infested sidings at Heap Bridge with a rake of loaded coal wagons, prior to rounding and propelling them into the north (No. 2) mill. The even more overgrown track in the foreground is the disused extension of the Heap Bridge branch, which originally continued for a short distance to the right of the picture. The buildings on the other side of the River Roch are part of Bridge Hall Mill, previously owned by James Wrigley, another paper manufacturer. This had at one time been one of the largest paper mills in the world, with its own internal railway system connected to the Heap Bridge branch via wagon turntables and bridges over the river, but closed in 1924. From 1928 the premises were taken over by Transparent Paper Ltd, manufacturers of cellulose film, who never used rail transport. (Richard Stevens)

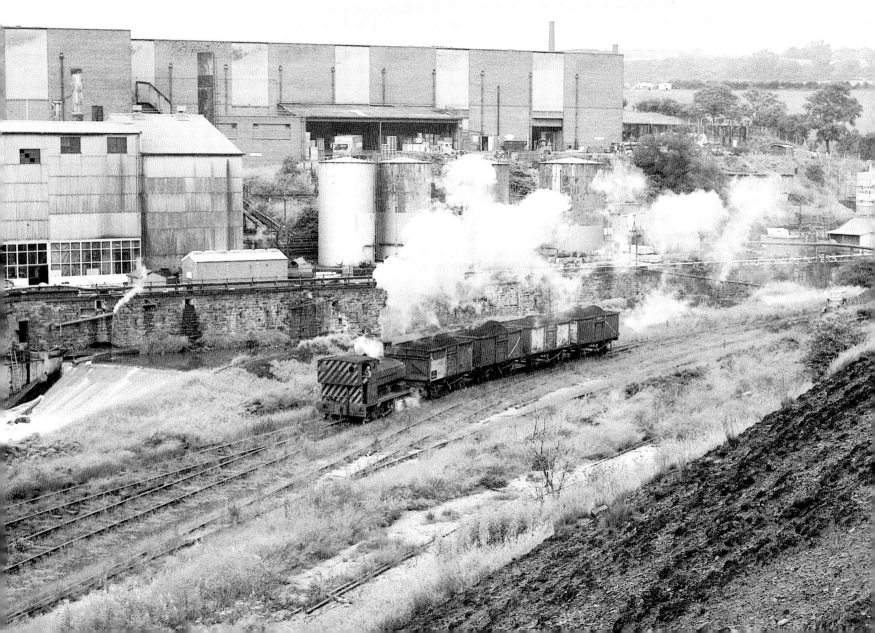

*Right*: The sole loco at Cooke & Nuttall Ltd's Vale Paper Mills at Horwich in the mid-1960s was Andrew Barclay 0-4-0 saddle tank *Douglas* (W/No. 2230 of 1947), simmering in the mill yard as the driver of a Fred Rose Ltd flatbed truck secures his load of finished paper and pallets. The Barclay was purchased new to replace a former L&YR 'Pug' (No. 11249, obtained from the LMS in March 1936), which was soon scrapped after the Barclay's arrival. The mills can be traced back to 1862 when Leonard Cooke began the manufacture of paper on the site of the erstwhile Vale Mills, producing chiefly wrapping and duplex papers. The mills were completely rebuilt and re-equipped in 1898, subsequently the only manufacture in Britain producing 'Kraft' heavy-duty brown paper, a brand name taken from the German word translating to strength. The mill took deliveries of its wood pulp, conveyed to Blackrod station from Preston Dock. The steeply graded line fell away from the exchange sidings to the mill. Road traffic took over from rail around 1967 and the mills finally closed in October 1983. (Stan Withers – author's collection)

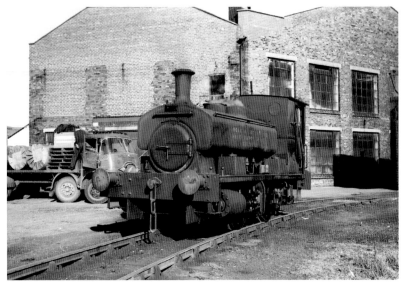

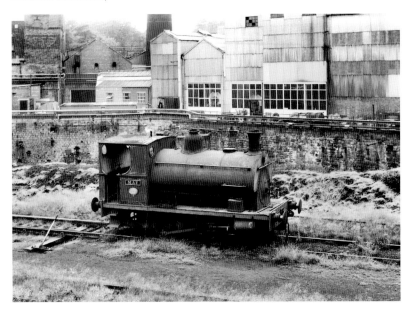

*Left*: The veteran R2 class Peckett *May* was still at work at Heap Bridge on 1 July 1970; in fact, she remained a working loco until the end of rail operations, believed to be during early 1974, but in later years was regarded as the inferior loco to the Barclay. A branch with a 1 in 80 incline from the Bury to Heywood line served the former Lancashire & Yorkshire Railway Heap Bridge goods depot, which in turn had a private connection with the paper mill. Occasionally this was worked by the Yates Duxbury locos, as well as by BR. (Author's collection)

*Opposite page*: Another view of Yates Duxbury's *May* working the Yates Duxbury branch from the north mill on a ledge high above the River Roch, with a laden internal user pulp wagon on a misty 11 May 1965. (Author's collection)

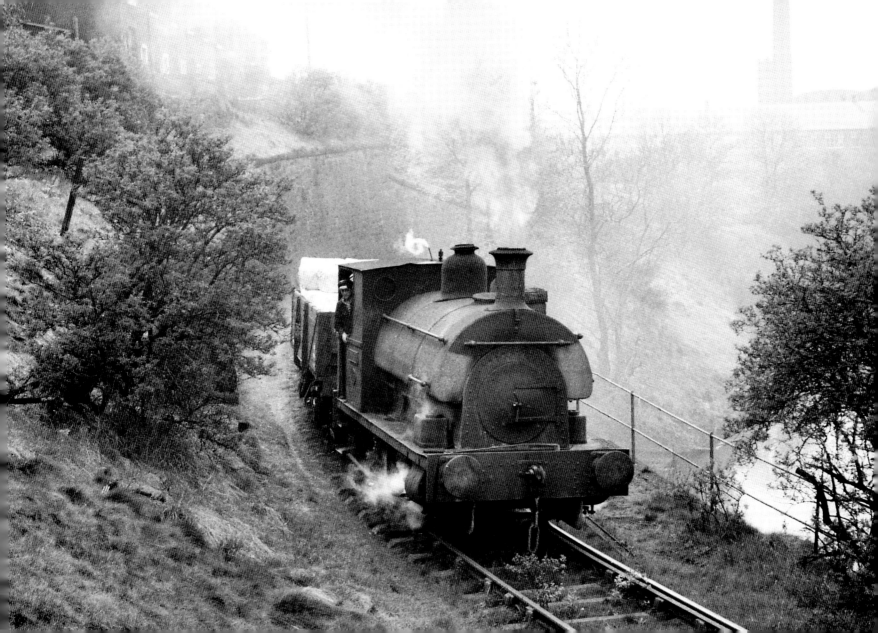

# 14

# CEMENT

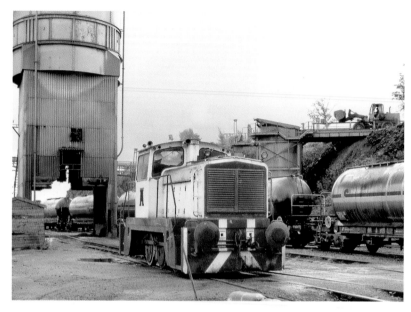

*Right*: On 3 September 1988, Castle Cement Clitheroe's General Electric 0-6-0 diesel-hydraulic No. 9 (W/No. 5401 of 1975) stands in the works yard between shunting duties. The loco was still active at the works in 2017. (Author)

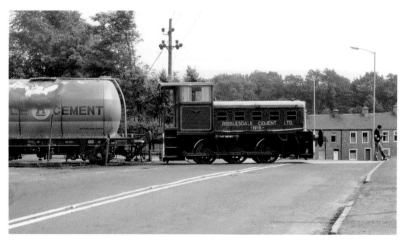

*Left*: Ribblesdale Cement's John Fowler 0-6-0 diesel No. 6 (W/No. 4240010 of 1960) tripping loaded cement tankers to the BR exchange sidings at Horrocksford Junction, Clitheroe, on 11 July 1979. The works was established in 1936 on the site of the closed Isis Portland Cement Co. Ltd. An adjacent quarry and lime works used a fleet of standard gauge four-coupled Hudswell Clarke saddle tanks, but this operation was superseded by dumper trucks in 1967. (John Sloane)

*Opposite page*: On 3 September 1988, General Electric 0-6-0 diesel hydraulic No. 9 shunts four-wheel bulk cement tankers at Castle Cement's silo loading point at Clitheroe. At this time rail traffic was worked to and from the Scottish Central Belt via the West Coast Main Line using pairs of BR Class 37s. Finishing this book on a high note, today the Clitheroe works continues to support rail freight, and a regular service of bulk cement is provided three days per week by DB Cargo via the Settle–Carlisle route to the Mossend railhead near Motherwell in the Scottish Central Belt. (Author)

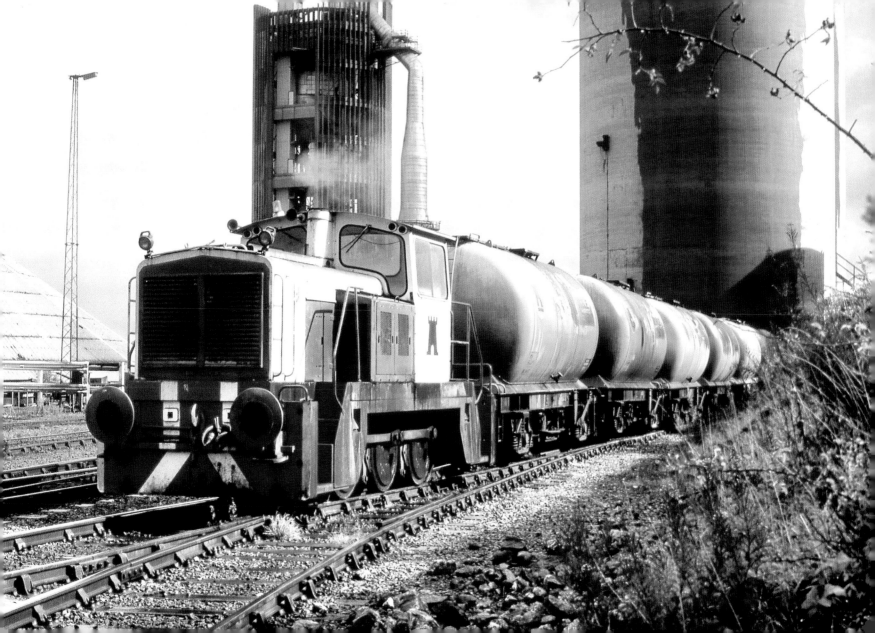

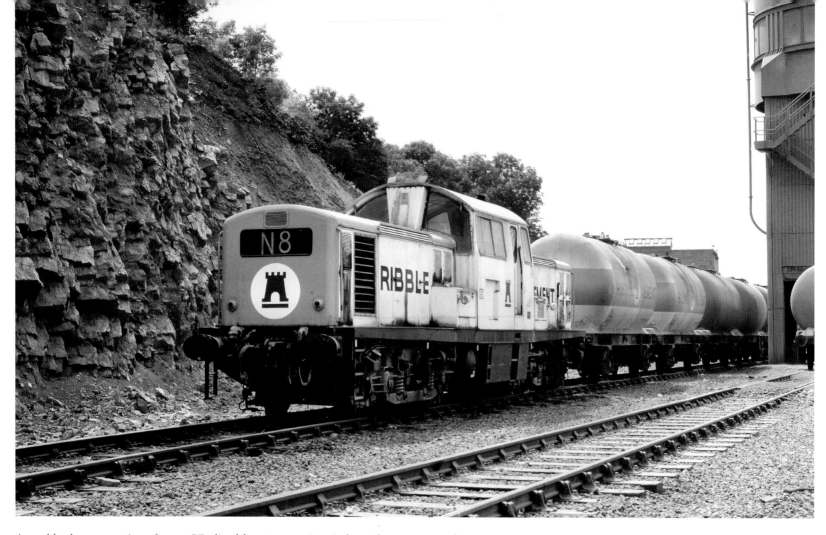

Arguably the most unique former BR diesel loco to pass into industrial service was Clayton Type 1 Bo-Bo diesel-electric D8568. It is the only surviving BR Clayton, owing its survival today to its period of industrial service in Hertfordshire at Hemelite Ltd, and subsequently from 1977 at Ribble Cement in Clitheroe, where it was No. 8 in their fleet. It had been withdrawn from BR Polmadie depot in October 1971 and worked at Clitheroe until around the first period of decline of rail traffic there, in 1982. It is now based on the Chinnor & Princes Risborough Railway. (John Sloane)